JOYCE TENNESON

a life in photography

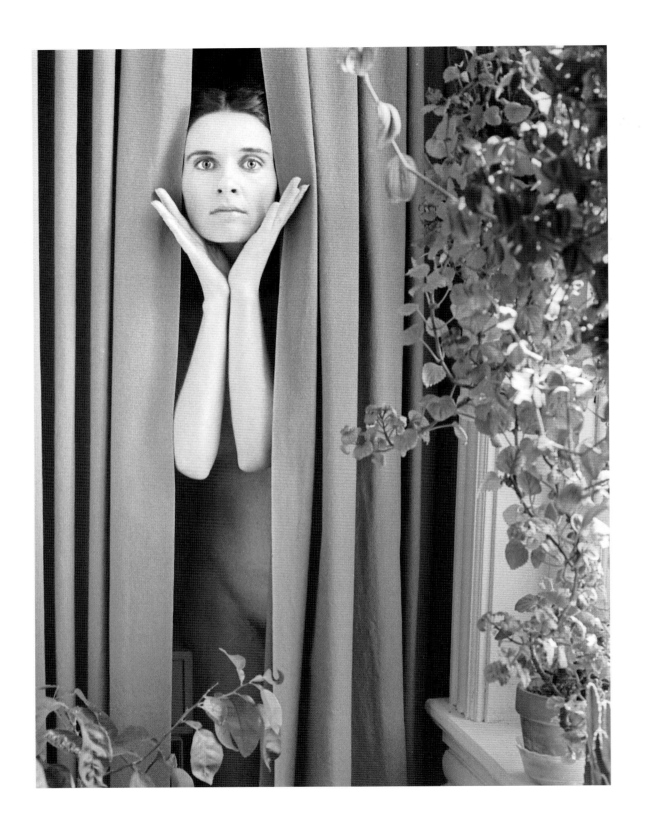

JOYCE TENNESON

a life in photography 1968-2008

INTRODUCTION BY VICKI GOLDBERG

A BULFINCH PRESS BOOK

NEW YORK | BOSTON | LONDON

Bulfinch Press / Little, Brown and Company
Hachette Book Group USA
237 Park Avenue, New York, NY 10017
Visit our Web site at www.HachetteBookGroupUSA.com

First Edition: April 2008

Bulfinch Press is an imprint and trademark of Little, Brown and Company

Library of Congress Cataloging-in-Publication Data
Tenneson, Joyce.
 A life in photography, 1968–2008 / Joyce Tenneson ; introduction by
Vicki Goldberg. — 1st ed.
 p. cm.
 ISBN-13: 978-0-316-00408-4
 ISBN-10: 0-316-00408-1
 1. Photography, Artistic. 2. Tenneson, Joyce, 1945– 3. Portrait
photography — United States. I. Title.
 TR647.T422 2008
 779.092 — dc22 2007032987

Design by Laura Lindgren

Printed in Singapore

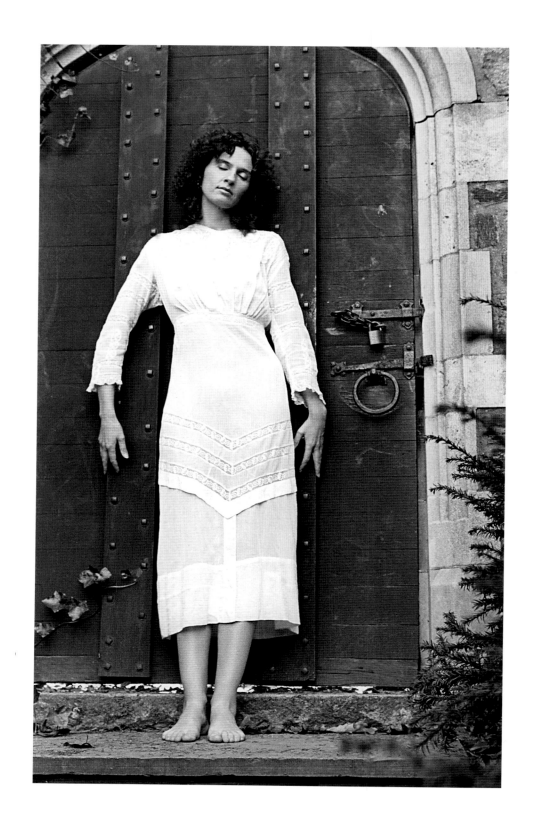

A Poet's Autobiography

VICKI GOLDBERG

A woman lies on the floor with an enormous pair of wings behind her, perhaps protecting her, perhaps promising flight but withholding it.

A woman on a bench is discovered by her double, her secret self, as if for the first time — and then the double turns her back and leaves her.

A woman broods, her face at the exact angle of the lacerated face of a doll in the window of a miniature church.

A naked woman stands against a great tree, spreading her arms wide, opening a shawl like a pair of wings, and giving her body to the air.

Self-portraits all, of a young woman in pain and in search of herself. The basic story is familiar enough: she is running between graduate school and a teaching job, having already put her husband through medical school. She has a little boy, a troubled marriage, and the gnawing feeling that she has no idea who she is and had better find out — if she is to have a life. The time was the early 1970s, when feminism seemed to promise women more than they had been offered before, and a story like this one played in the minds of many. Some who were strong-willed and lucky enough to be gifted turned their search into a narrative that gave them voice and spoke to others as well. This book is one such story — Joyce Tenneson's — and like all important stories, it resonates beyond its particulars. It is certainly a tale of its times, couched in a highly individual language, piercingly beautiful, that swings between darkness and hope, sorrow and transcendence. It relates a personal journey that began with these early pictures and has never quite stopped.

The first steps of self-exploration meant recording her own thoughts and appearance with her camera. Along the road, self-portraiture shifted narrowly away from Tenneson herself to surrogates: intense children, sometimes her son, Alex (who looks so much like her that her photographs of him are like echoes; she has said that photographing him was like photographing herself), then on to young women who embody an ideal of beauty that might have emerged from the same gene pool as the photographer, and on to hefty middle-aged women and frail older women, who are like signposts on the path to the future, arriving, years later, at Tenneson once more. The images are all aspects of Tenneson's own story, an oblique record of her journey, her curiosity about the future, and her thoughts about women's pilgrimage through life. This book, indeed her many previous books, can be read as a continually unreeling visual autobiography.

It's a poet's autobiography, written in graphic metaphors. Artists' autobiographies run in different grooves: Rembrandt recorded a chronology, Schiele his obsessions, Picasso the circumstances of his love life. Tenneson's is an exploration of fears, wishes, and the discovery of an inner flame—but she never forgets that the candle eventually dies into darkness. The personal is the political: this is a history that flows from personal events and feelings and then ripples out from its singular subject to the commonwealth of women who lived through the women's movement, whether they marched to the barricades or not. That movement inserted issues of female identity, sexuality, and autobiography, as well as controversies over the place of motherhood and domesticity, into the public agenda and the minds of many women. Tenneson's work bears out a bit of wisdom that Diane Arbus said she learned from Lisette Model: "The more specific you are, the more general it'll be."[1]

Tenneson's teachers had told her that with the names Joyce and Tenneson she was destined to be an artist,[2] but before she could be anything she had to be herself. It is not uncommon for young people to be strangers in their own lives, and women at that moment in time were

hearing the message that whatever they had been told, whatever had been expected of them, they were capable of being something more. Tenneson turned her camera, an unforgiving monitor, on her outward self in an attempt to discover the stranger within. What she recorded was in most instances a vulnerable woman, unable to fly, morose and pained except when one with nature.

She pictured herself in a dark dress, standing in a field of empty metal bed frames (p. 46). There she appears to be presenting us with a hospital for the hopeless or a Flanders Field of those who have died in these beds. Tenneson says she was so depressed about her life at that time that she considered suicide, but, instilled with a rigid sense of responsibility, she decided to put off dying until the end of the semester so as not to leave her students in the lurch, and by then it did not seem so urgent. In another picture she lies naked on a stone parapet, her

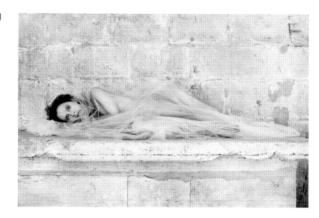

body covered in gauze, a delicate feminine armor that can scarcely shield her body from view or protect her from whatever future she is staring at (above right).

Transparent fabrics, veils, draperies as delicate as spiderwebs, play simultaneously with the ideas of concealment and revelation, of seeing past our preconceptions into some aspect of truth. In one early picture Tenneson is wrapped entirely in lightweight material, even her face covered with a gauzy scrim—she says she felt she was suffocating, something she could not have verbalized then that nonetheless came out in her pictures. Later, when she had found the life she was looking for, her face came into the open. The gauzy drapery over so many bodies throughout her work more likely implies that what we see is partly hidden, that reality is masked—an idea that has been with us since Plato's cave.

When Tenneson's son was little, babies turned up in some pictures like plump promises; in one image a tiny foot pushes its way into the

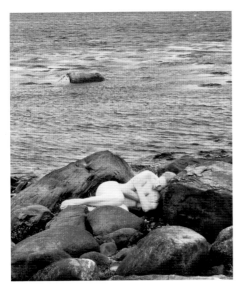

photograph of a recumbent woman like some intrusive miracle (p. 62). Beginnings and endings: babies, as obviously as they embody life's beginnings, also, in their rapid changes, remind us of life's relentless progress, which Tenneson never chooses to ignore. She photographed the old as well as the new. In one image, a headless, anonymous woman reclines in the same kind of silken robe as young women do in these pictures, but her fingers are gnarly and her hand is ridged with prominent veins.

The one site of freedom, of the possibility of flight, is in the midst of nature. As a child, Tenneson had gone into the woods near her house to relieve branches of their winter burden of snow, allowing them to spring up lightly, and she folded her poems into paper boats that she set loose on a pond. Now she photographed herself more than once allied to a tree in pictures reminiscent of Anne Brigman's dramatic self-portraits in the wild in the early twentieth century. Brigman, like Tenneson, worked at a moment when women's liberation was in the air and women were beginning to identify themselves as guardians of Mother Earth in opposition to the long-term, male notion of dominating it. Photographs, like the people who make them, are embedded in their eras; they document history whether they are meant to or not.

In Tenneson's scheme, even nature, which affords a sense of union and the possibility of liberty, carries hints of mortality. At one moment Tenneson floats serenely among lily pads, at another she drifts down a stream like Ophelia. Yet nature's promise of renewal persists, as in a more recent photograph (above left), where Tenneson curls up naked among rocks by the sea as if waiting to be waked by the tide.

By the time she began seeking herself in images that swam into life in a darkroom, the women's movement had bestowed on American women artists, whether they'd been to consciousness-raising sessions or not, what men had long considered a right: the power to express themselves, the belief that they should, permission to examine their lives and potential. Auto-biographical fiction by female authors elbowed its way into the discussion:

Erica Jong's *Fear of Flying*, Marilyn French's *The Women's Room.* Tenneson was aware that other women were also struggling with their lives. Having dreamed that she was walking through snow carrying a birdcage but could not open its door, she reenacted the dream (pp. 22–23), but kept the woman faceless and anonymous, because "I was trying to be every woman. I knew I wasn't the only caged bird out there." Because she was teaching art, she recognized that many women photographers were also telling their own emotional stories — think of Francesca Woodman, Adrian Piper, Nan Goldin. Tenneson placed an ad calling for photographic self-portraits for a book project. The photographs flooded in until she had no room to spread them all out. *In/Sights,* which she edited, was published in 1978.

Like Tenneson, many women at the time were exposing their bodies as one avenue to self-discovery. (This was also a means of reclaiming the gaze from the men who had staked their claim on it long ago, and men were not about to give this up: women displaying themselves nude were often criticized as narcissists.) Like Tenneson, who had trained as a painter, many women artists were flocking to photography, in part because there was no old boys' network to keep them out, as there was in painting and sculpture. Still, the critics were men. When Tenneson first started showing the ethereal, parchment-colored images represented here, reviews trounced them as "women's work," and one male photographer told his class he wouldn't use her photographs as toilet paper. Nothing stopped her. Once the photographic world grew large enough to recognize that women could be artists too, Tenneson began to receive what would become a long list of awards.

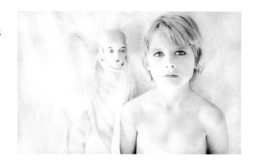

The early self-portraits include smiles as well as a boundless commitment to loveliness, but the mood for the most part is quietly sad or stark or vulnerable. These images are interspersed with photographs that dwell on the elusive and powerful mystery of light playing over her son's skin, or upon a silky gown, or a thin veil through which one eye regards us. Light in these pictures eats away at solid existence. The richness of light, the one constant of

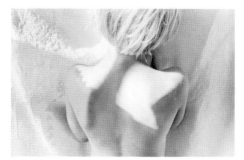

the photographic medium (and a fascination evident throughout Tenneson's work), bleaches flesh and fabric, even lace, as if trying to erase them with its gentle persistence but only proving itself indifferent to difference. Little but nuance, outlines, and facial features, occasionally assisted by middle-weight shadows, separates skin from fabric or china from wall in these pictures. Everything partakes of the same substance and condition.

A little later the delicate platinum monochrome of these photographs sounds a deeper note, closer to earth, a soft gray and a grayed-down white, even in the color photographs, which do not begin until the mid-1980s. By the late 1980s Tenneson turned fully away from black-and-white to color. The soft glow and penumbra persisted—no longer the subdued murmur of pale silver, the photographs turned chalky, autumnal, hazy, as if silence and time had muted her subjects and the atmosphere they moved in and both were slowly, ever so slowly, courting oblivion. Mortality continues to hover like a wraith over many pictures and transience like a weather front on the horizon; a faint melancholy, the color of a cloud, drifts over many of her images.

Skin tones stepped in when Tenneson turned to color, but they were frequently tamped down, sometimes even powdered—figures as white as ghosts, against the pallor of stone or mist—and backgrounds tended to harmonize with the colors as well, almost as if they were variations on one another. Tenneson paints her own tremulous backgrounds, some with suggestive reliefs or architectural motifs. In certain pictures in her other books, people seem to turn into or evolve from stone, like someone who has looked on the head of Medusa, or Pygmalion's god-touched statue.

The tonal evenness and close hues of so many of Tenneson's pictures, especially in some of the color photographs, are aesthetic devices that also suggest that the disparate components of the material world are less separate than we think. In some pictures, the sense of light generously and evenly gracing whatever it touches hints at equivalence, the unity of matter—ordinarily not a visual issue but one for physics. There is a faint echo here of an earlier American idea, the transcendentalist notion of

cosmic unity. Emerson's "The Over-Soul" (1841) described it as "that Unity, that Over-Soul, within which every man's particular being is contained and made one with all other," and Thoreau, in the chapter of *Walden* called "Solitude," wrote, "Shall I not have intelligence with the earth? Am I not partly leaves and vegetable mould myself?" When Tenneson's photographs mute the distinctions between flesh and silk, body and background, the aesthetic means hint that a continuous process of transformation underlies existence, a process relevant to psychic lives as well — note that one of her books is titled *Transformations*.* This is a word that turns up repeatedly in women's literature of the seventies, suggesting that women have the power to change themselves and their lives,[3] a conviction that has powered Tenneson's own life. Her later images of confident and accomplished women bear eloquent testimony to change.

Her search for self evidently found its destination. A photograph of herself wrapped in gauze and straining against it with her legs open (p. 51) might be read as a woman fighting her constraints, but the photographer regards it as an image of giving birth to her new self. Inspired and fortified by Joseph Campbell's insistence on a universal myth of a journey that is the only way to find the true self, she left her job and home and moved to New York in 1984 to try to make it on her own as a photographer. After months and months spent drowning in anxiety in Manhattan, she finally won assignments, and as her reputation grew she earned enough from her commercial work to pursue her inspirations.

More often than not, her subjects since then have been young women of an uncommon type of beauty that is like a signature of Tenneson's and has real affinities with her own appearance. Her subjects and images have always dwelt among beauties that lie along the edges of perfection — physical beauty, spiritual beauty, beauty of tone and color, but also

*I wrote the introduction to this 1993 book.

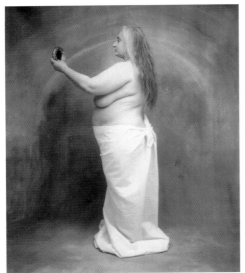

the unexpected and disregarded beauty of the old and imperfect. She has seldom lapsed into prettiness, and her refusal to exclude the disappointments and decline of life amount to a rebuke to the continuous stream of ever younger and younger women in advertising, fashion, and pop culture, an imagery that implies that only sexy, vibrant youth counts, that maybe it alone *exists,* in this world. When Tenneson started photographing, and for years afterward, beauty was a quality that art disdained; only recently, and cautiously, has it been readmitted into the precincts of acceptable aesthetics. Tenneson, unconcerned with trends, has never wavered.

When she photographs heavyset, maternal figures, they are apparently as comfortable with their bodies as most women could only wish they were, and they have a weary but unmistakable gravitas. One is a *vanitas,* one attempts to comfort another, still another instructs a child in what looks like a sorrowful lesson about life's journey. Tormented children make an appearance: one confined by veils stands next to a drawing of a powerful severed leg and cries out (p. 80). The pain of the earlier work is not forgotten: the purgatory of the soul is cased in the loveliness of flesh and light. Even those in the perfection of their youth may suffer. Or they may boldly coexist with or confront life's perilous mix of promise and threat: one young beauty, unafraid, is garlanded in the jaws of a shark. The models are largely naked, sometimes cloaked in gauzy veils, sometimes draped in timeless garments. As time and photographs went on, they tended to become increasingly self-assured, some even transfigured.

What began with self-portraits that illustrate an overt, if symbolic, autobiography was now related through avatars, as autobiographical fiction is. An old man refuses to pay attention to a desperately beseeching child whose back sprouts the wing of a bat (p. 75); Tenneson says the man is her father, who was always turning away. A young woman holds a mirror that reflects her face upside down, where it looks markedly different; the pho-

tographer says, "She is me, looking inside, trying to understand, to lift layers off my being. I think I'm still trying to do that."

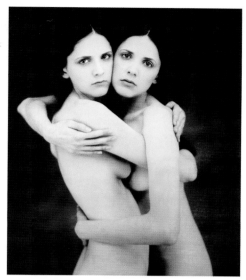

And, she adds about this picture, "it feels religious: the shape of the host." Brought up Catholic but no longer traditionally religious, Tenneson is strongly attracted to religion and deeply involved in the spiritual side of life. (She says that "spirituality and sensuality intermix in my obsessions.") An unusual background hides in plain sight in her work. Her parents worked for a convent, and she spent her childhood among nuns and rituals. She and her two sisters dressed as angels for Christmas pageants — Tenneson daydreamed often about flying — and they wore white on May Day. Her mother was an identical twin and saw or spoke to her twin sister every day. Allusions to these early experiences persist in her work, where wings and twins recur — at one point her son is almost her twin, at another, actual twins gaze at us fiercely — and a semblance of angels finds its way onto the page. And throughout, signs of torment and redemption, and an aura of secrets and mystery.

In later photographs from the series "Light Warriors," the pilgrim arrives, at least momentarily; the journey from despair has reached triumph. Not that that is unalloyed, but it exists. Young women become so free that doves light on the shoulders of one like guardians or surrogate wings, and another has a translucent pair of wings blazoned on her chest. Some of the women in such pictures were immigrants, whose search for a place to stand in life was more complex and demanding than most; Tenneson was curious about the spirit that drove and sustained them. Light in such pictures is no longer indifferent but burns into the surface in the shapes of halos or revelations, in and around figures that are in the process of turning into light or may have been light all along that was obscured by the concrete forms we are more accustomed to. A woman with a wreath of dry roses has radiant streaks of light about her head; another, a self-portrait at age fifty-two, has hands that blaze light like two small suns (p. 113) — women not only powerful but transcendent. Tenneson intends

these images as signs that light is the emblem of an otherworldly force: "Light strikes like an annunciation—you have greatness within you—or emanates as if to announce that the divine spark resides within flesh."

As Tenneson was approaching sixty she began to wonder what it would be like to be that age and older. The population was aging and the consequences of age, a subject most happily ignored, were edging their way into public discussion. Photography itself was more openly addressing the subject, which had been largely suppressed and repressed even

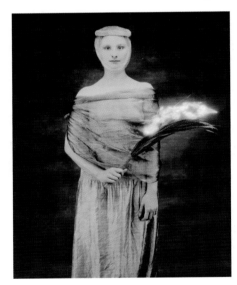

by artists in past centuries (except when they glorified saints and sages). Nick Nixon turned a sympathetic but unsparing camera on the elderly in nursing homes, John Coplans revealed every sag and crease of his aging body. Tenneson was surprisingly optimistic about older women, a large group often relegated to the ranks of the invisible. She filled page after page of a book called *Wise Women* with images of older women who were mostly gray and wrinkled yet still vividly alive and astonishingly lovely. This book declared that age could not wither nor custom stale the infinite variety of a woman's years.

In celebrating age in an era relentlessly growing older and inventively determined to deny it with silicone, Botox, and plastic surgery, *Wise Women* spoke to the traditional notion that age and wisdom grow in tandem and might even leave ugliness outside the door. But no one in that book, fortunate as they were to have faced the years so splendidly (and found a photographer to show them at their best), was trying to fool time and death. These were not immortal girls but mortal women with good bones that would soon enough be all that was left. Tenneson speaks of the elderly as being between two worlds. In one photograph (p. 119), an eighty-five-year-old woman begins to blur at the edges, as if she were sloughing part of her essence or acquiring an aura from beyond.

Tenneson's flower pictures are another venture into the realm of perfect beauty that has already been addressed in faces, bodies, and imagery. They are portraits of a kind too, each flower distinctly individual,

as alive as any of her other subjects, and immortalized, like them, at a moment of blossoming. Then in the end, we are back to self-portraits, free in nature once more. This book begins with an image of Tenneson peering through parted curtains with her face between her hands — coming out of a dark space and presenting herself to a room full of light and growth. At the end of the book, she sits outside in the light before an old, peeling door, her face again framed by her hands, looking not so directly at us as at the world. Earlier she was looking for a way out; now she has clearly emerged. The door behind her, perhaps the entry to or exit from the life she left, is closed. If, as Tenneson believes, a woman's life is a pilgrimage, then the journey never ceases and there is no return from it; once embarked, one is thrust into life, which asks those on the journey to face it squarely, with a steadfast gaze.

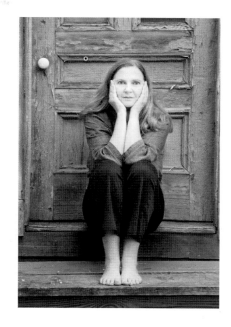

Notes

1. *Diane Arbus* (New York: Aperture, 1972), p. 2.
2. Tenneson has written about her life and been interviewed many times. Most of the personal information in this essay was related in an interview with VG in January 2007.
3. See Lucy R. Lippard, *The Pink Glass Swan: Selected Feminist Essays on Art* (New York: The New Press, 1995), p. 18.

E A R L Y

W O R K

"My early self-portraits appeared effortlessly
and seemed like equivalents for my deeper emotions.
Without knowing it, I was trying to peel back the layers
that shroud and bind us all as we struggle
to reveal our own authentic selves."

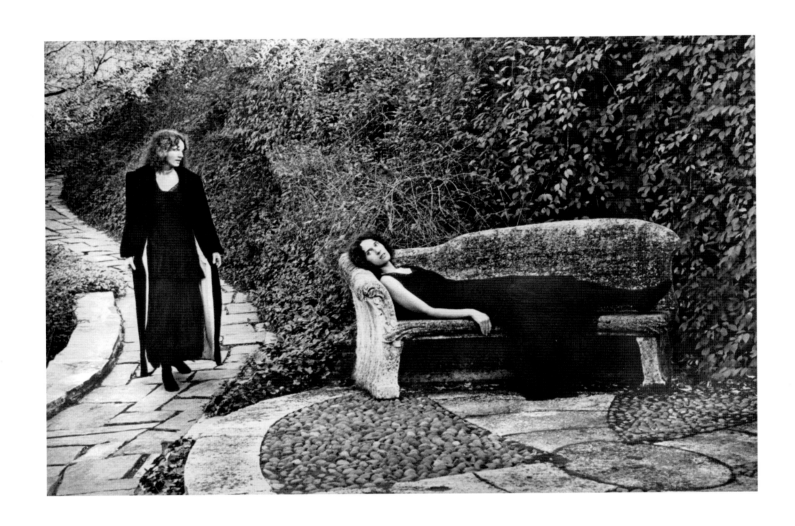

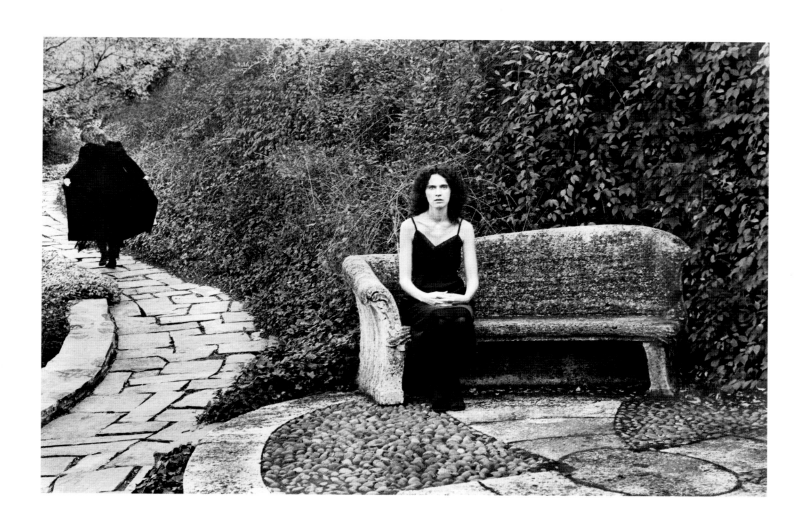

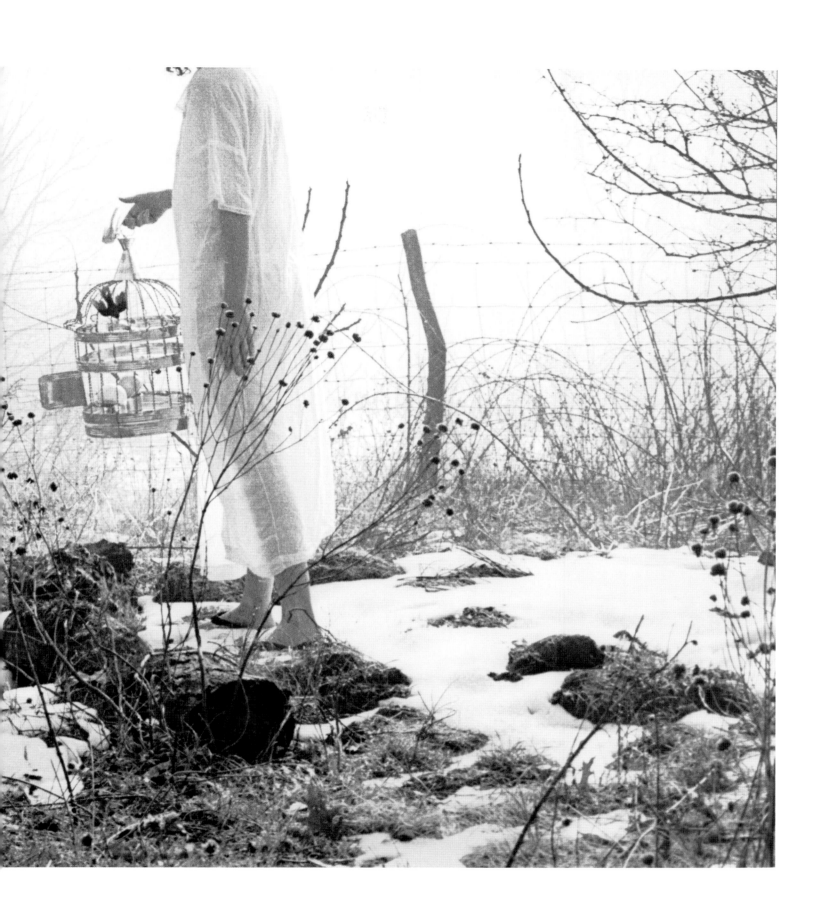

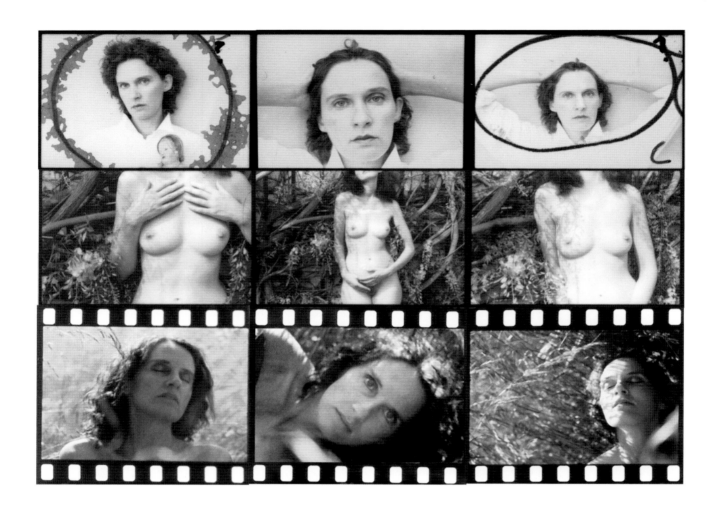

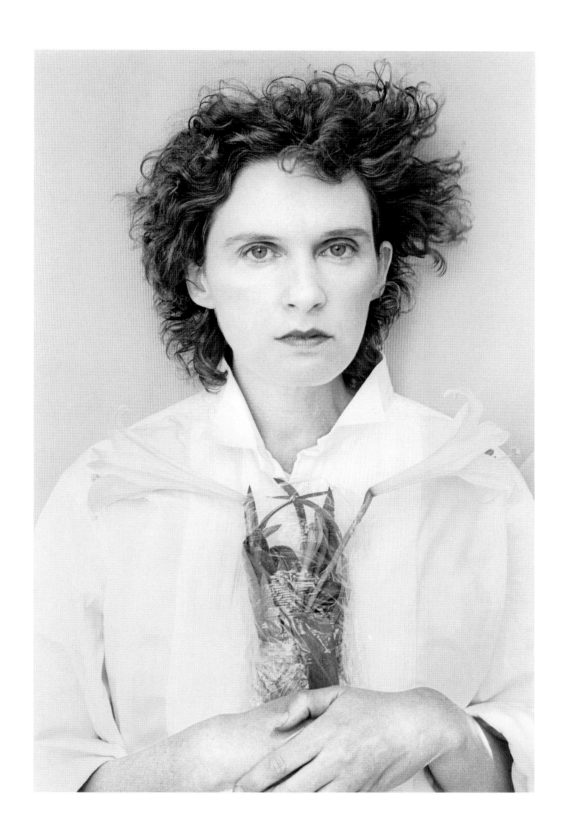

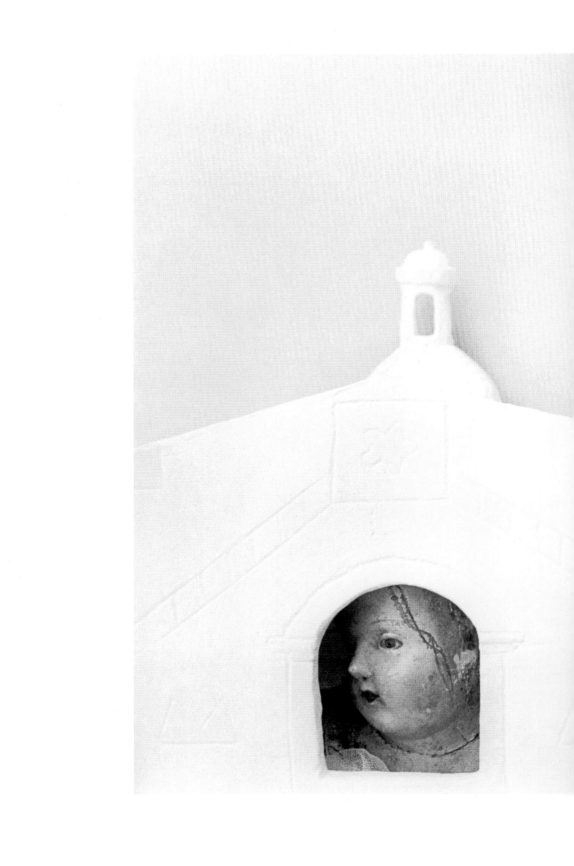

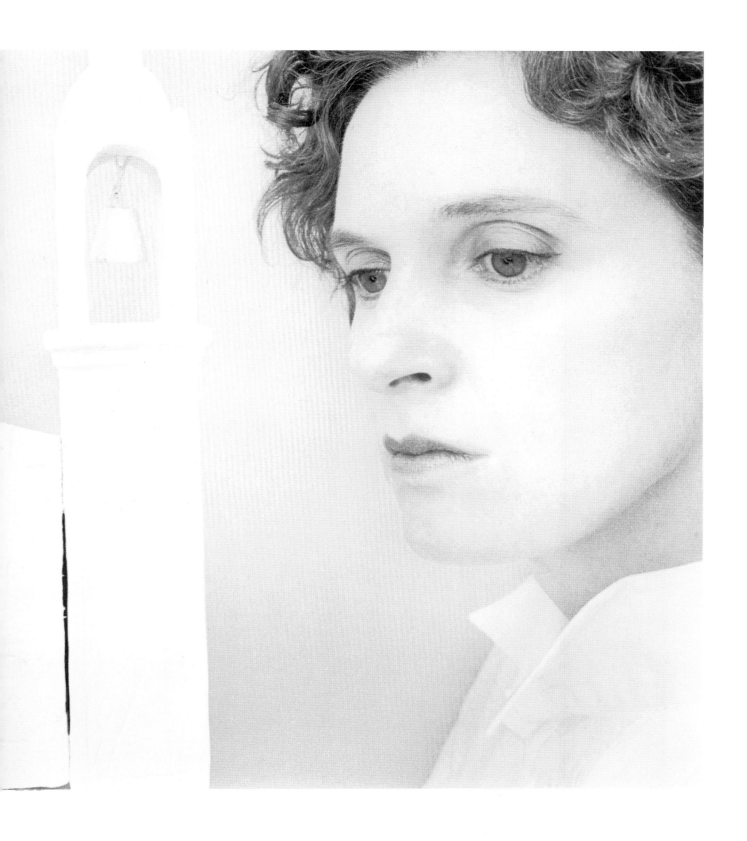

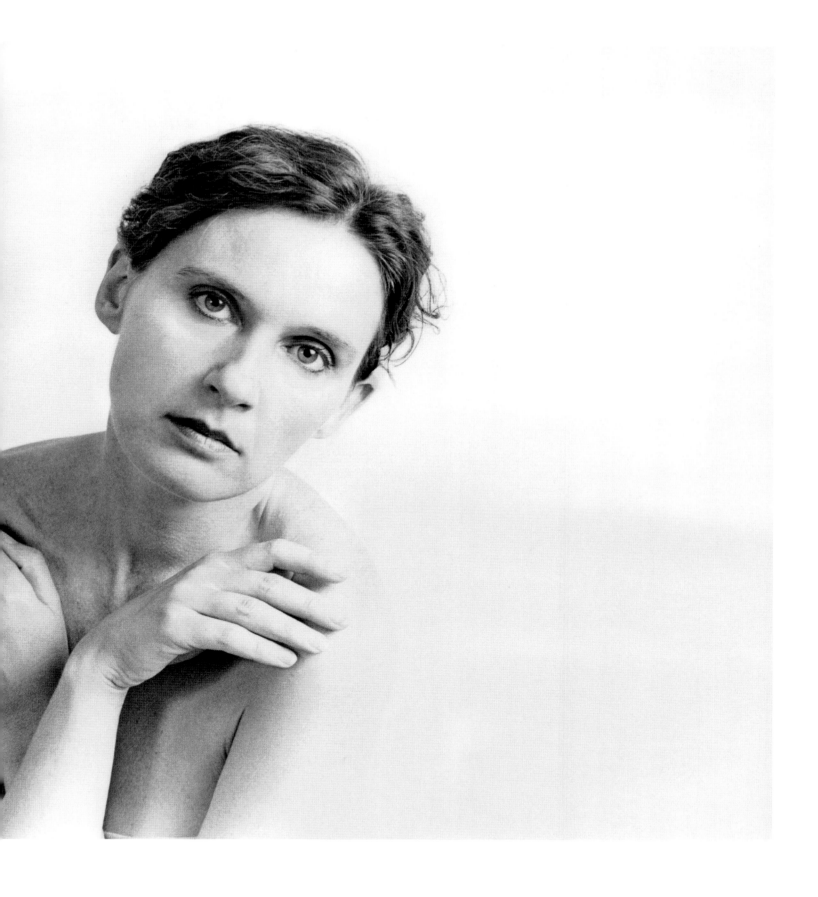

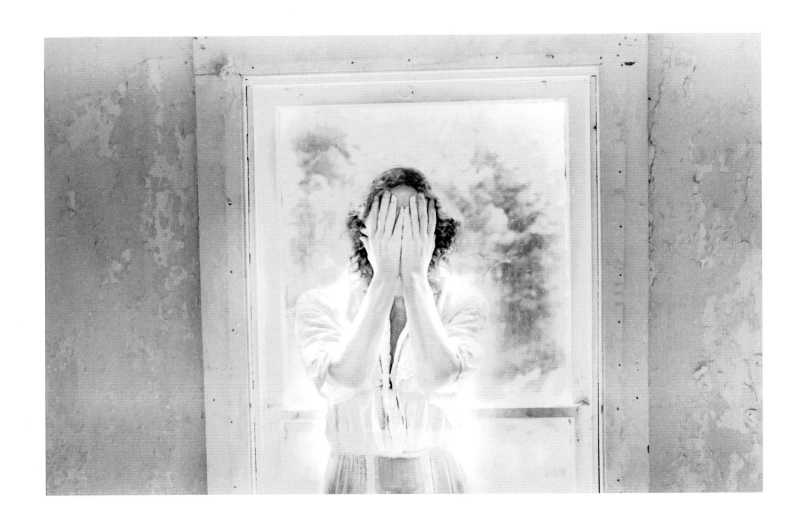

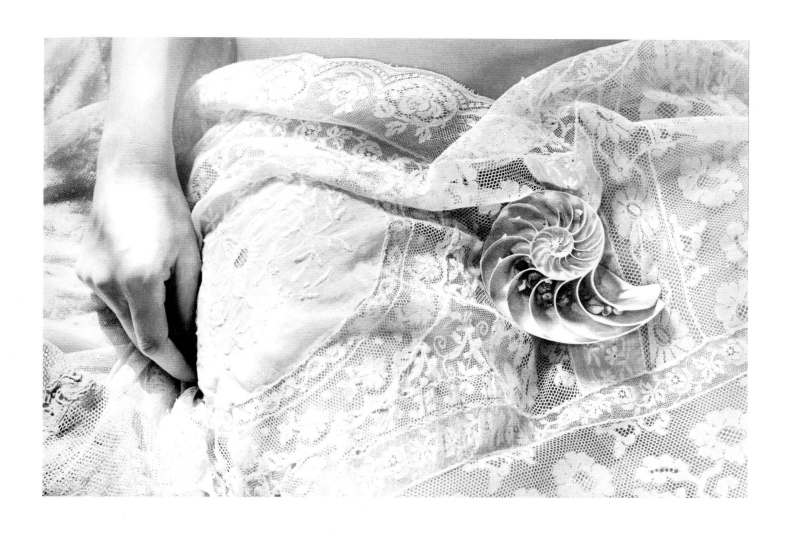

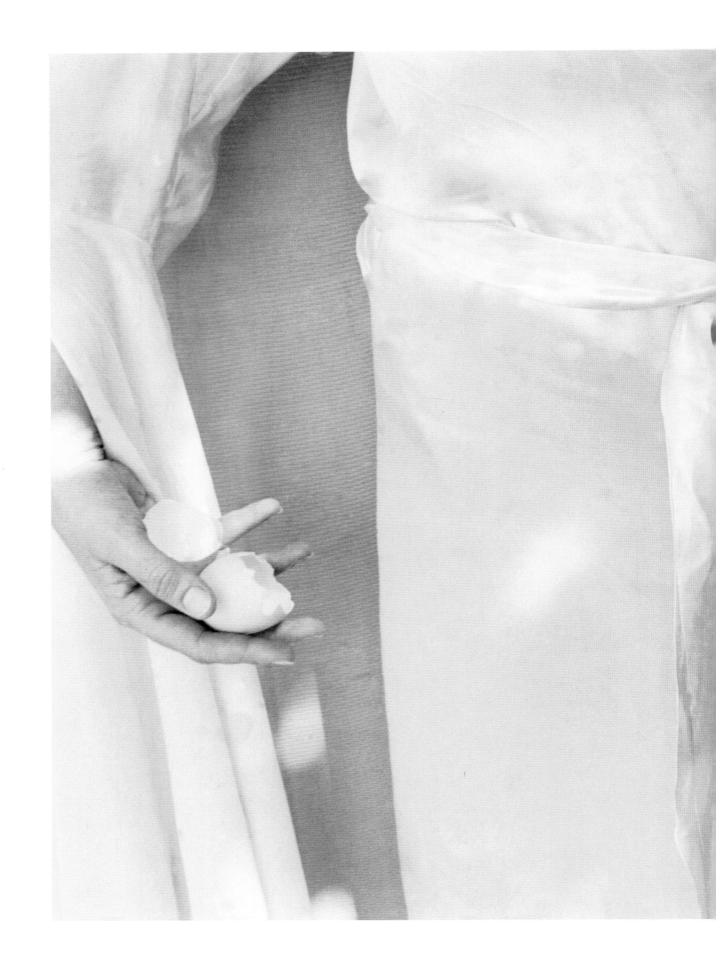

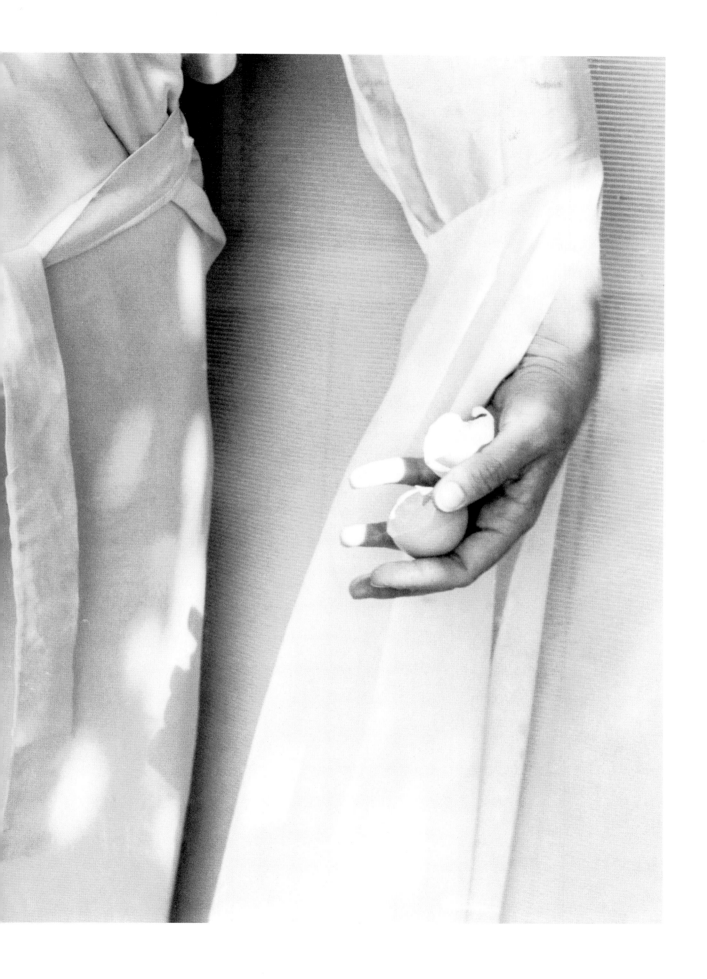

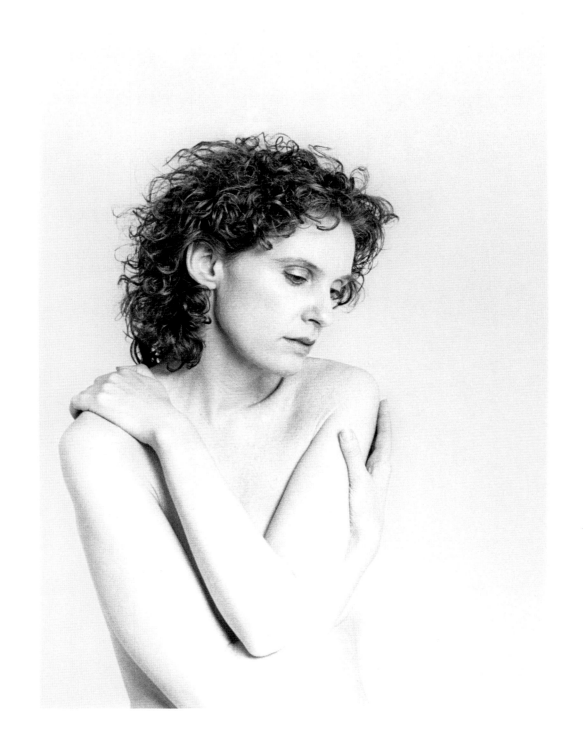

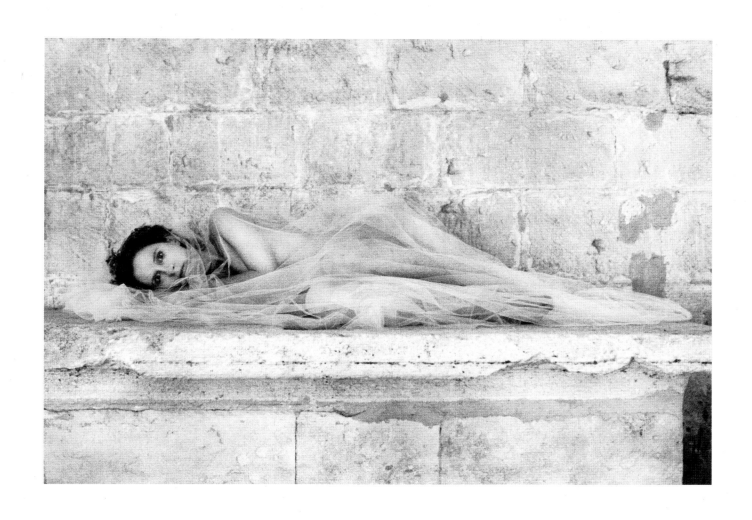

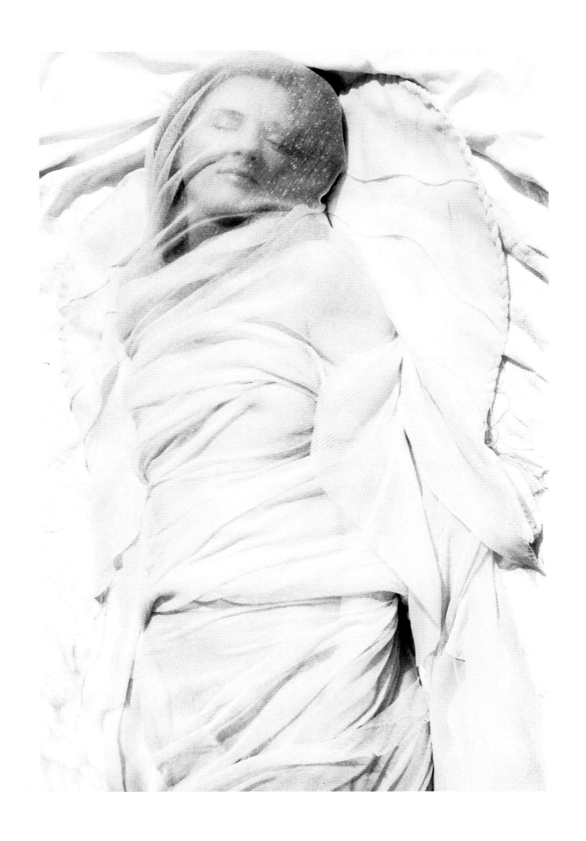

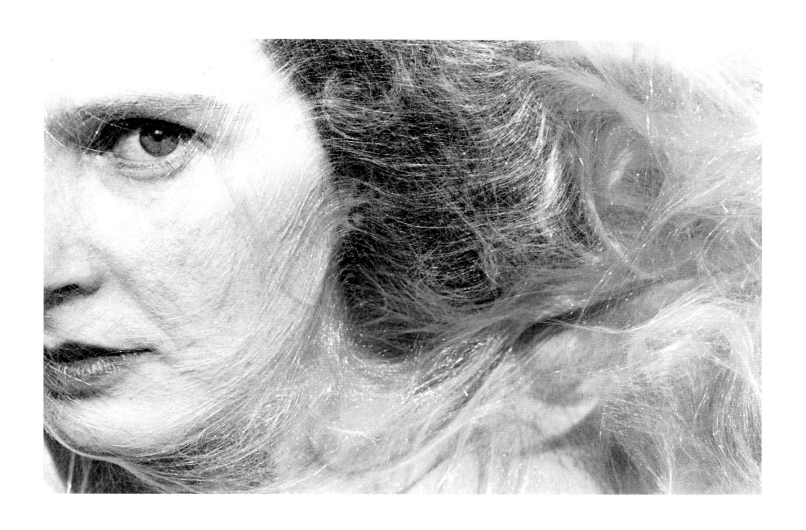

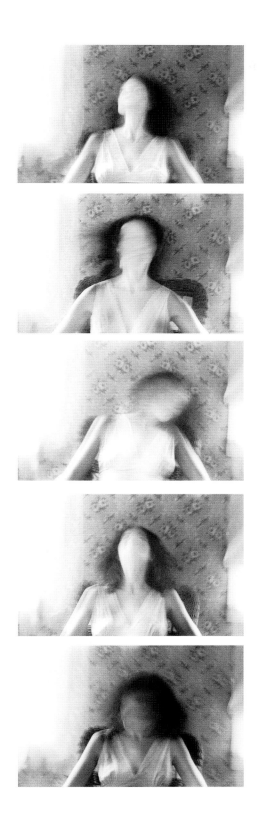

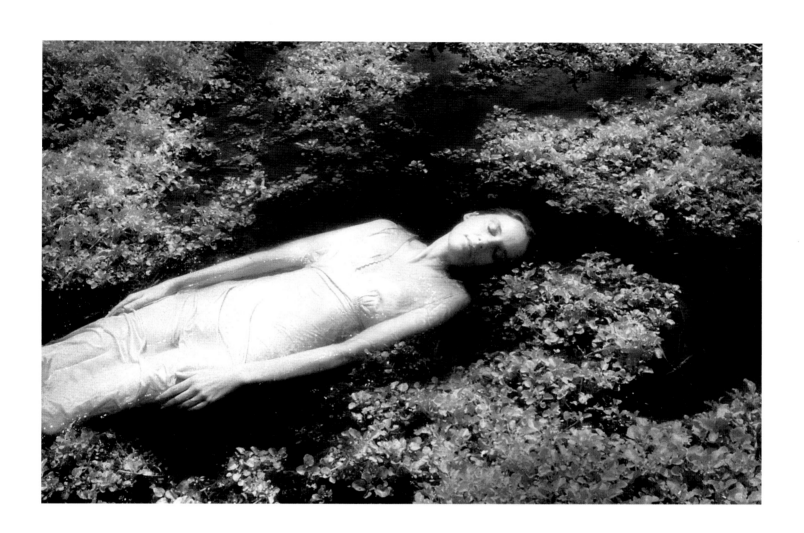

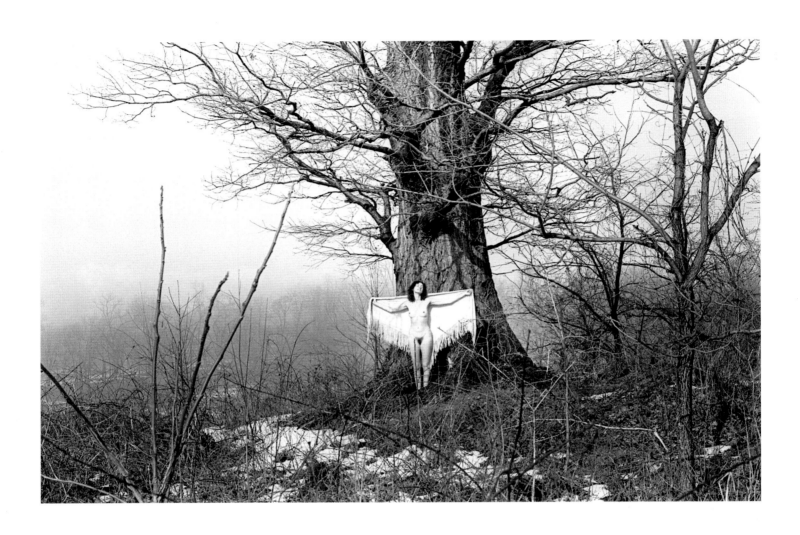

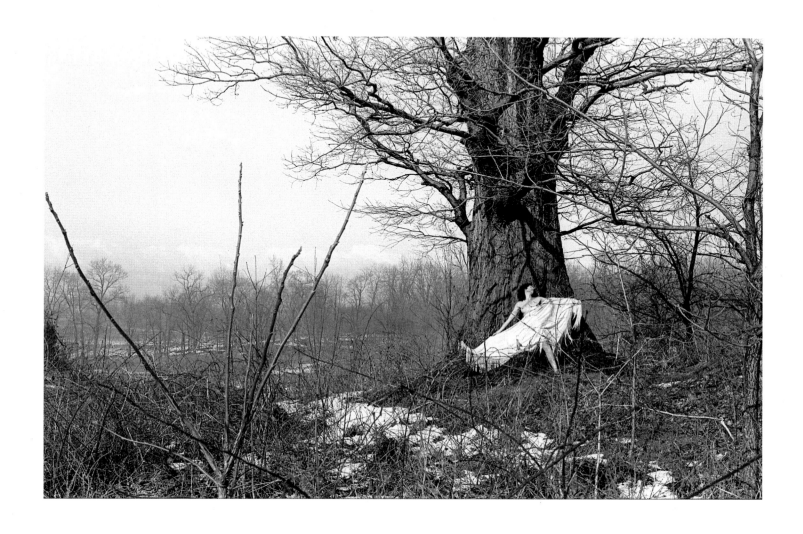

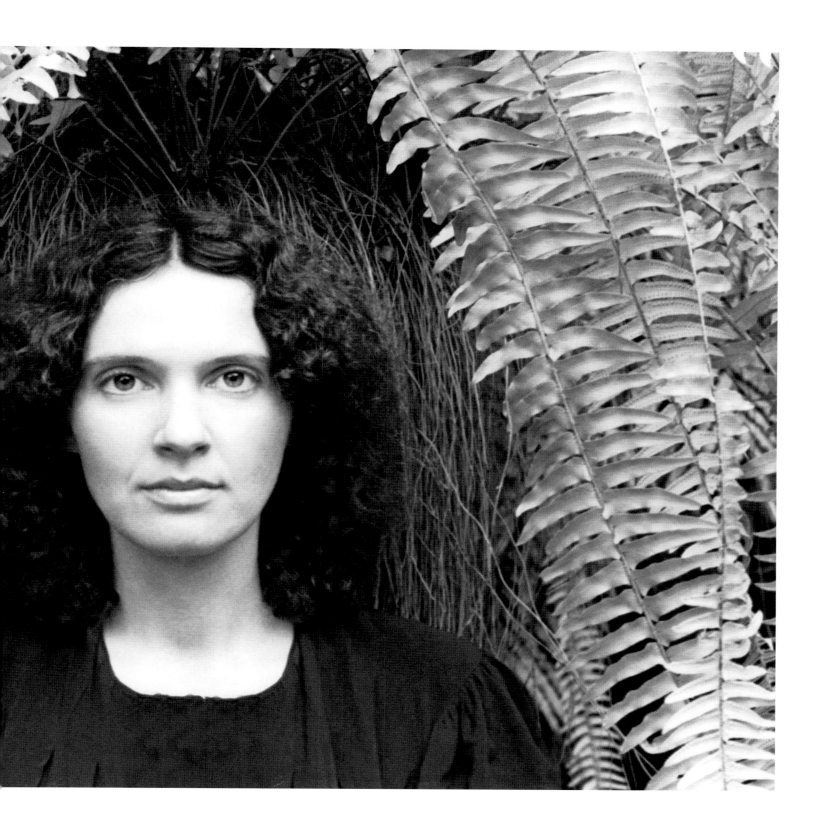

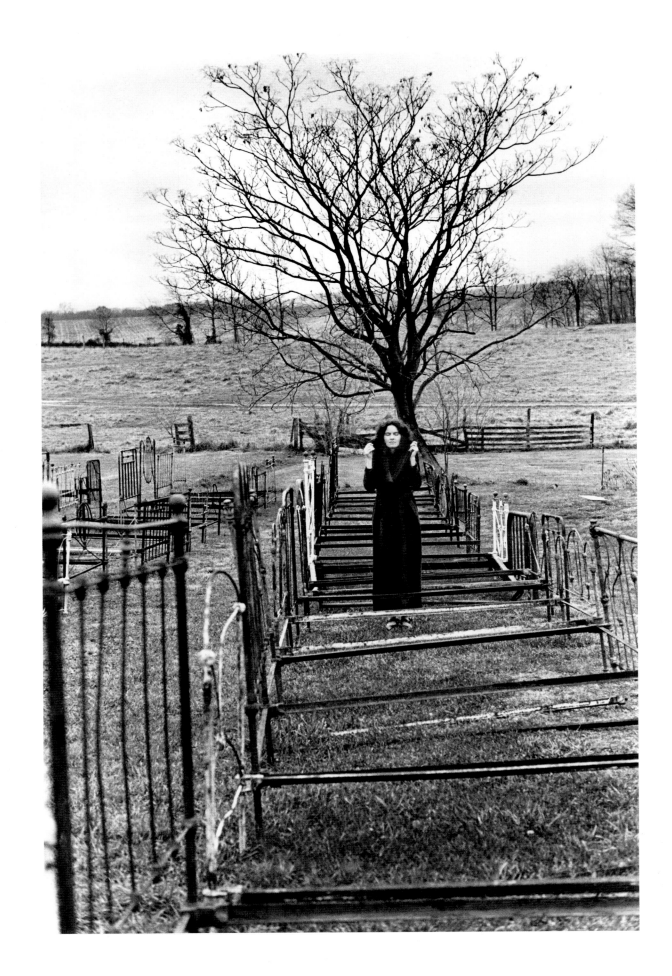

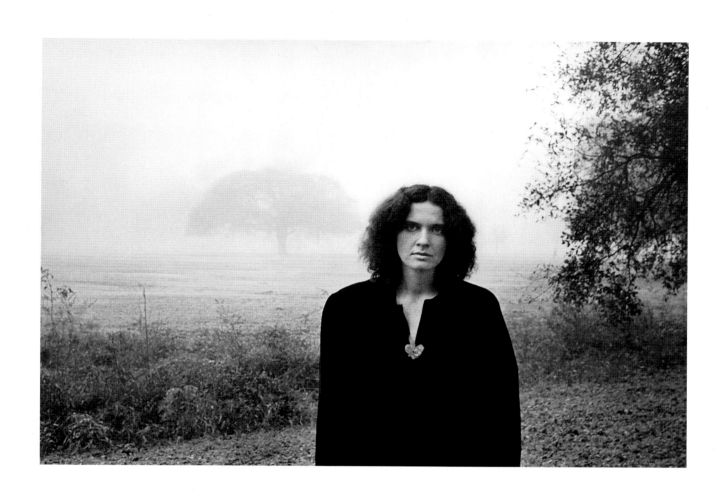

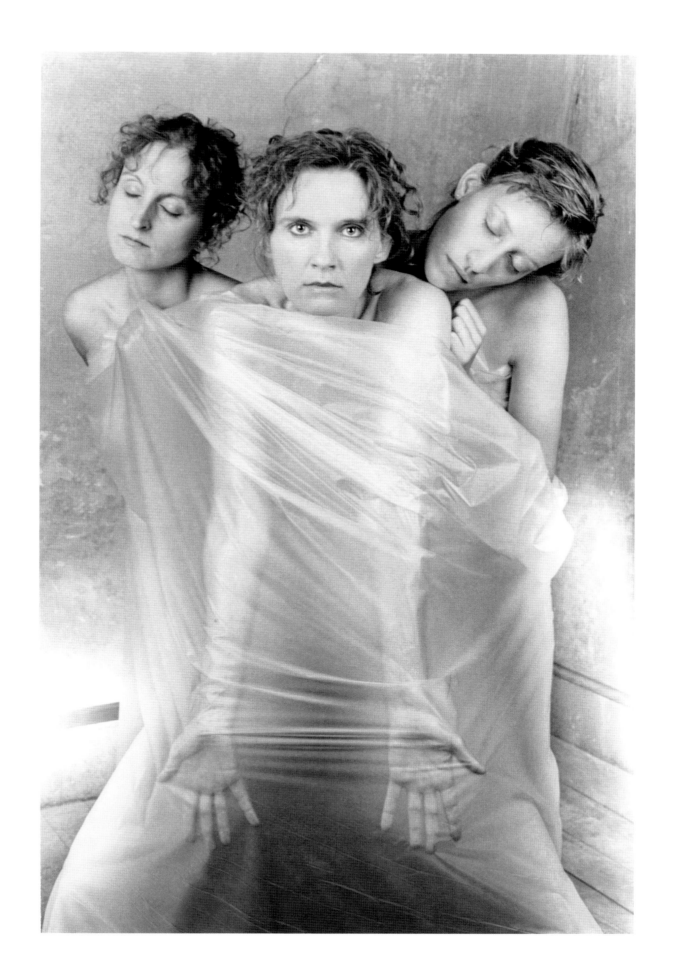

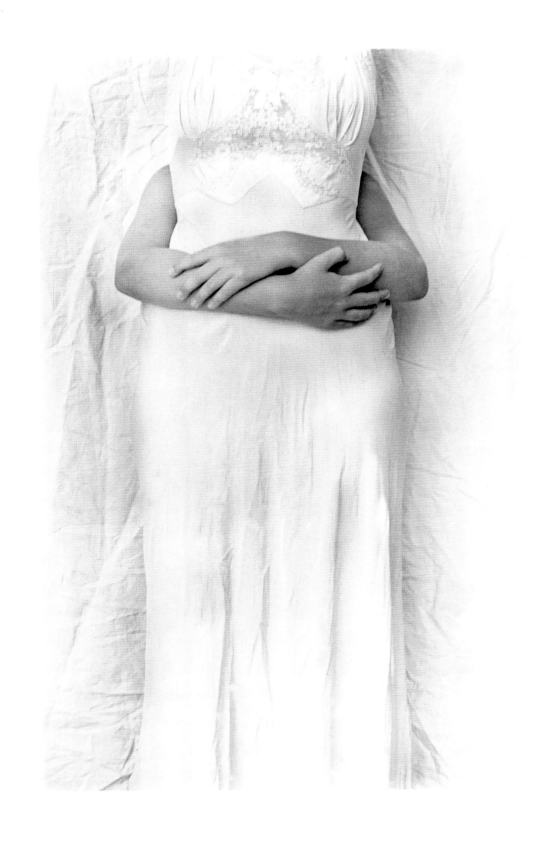

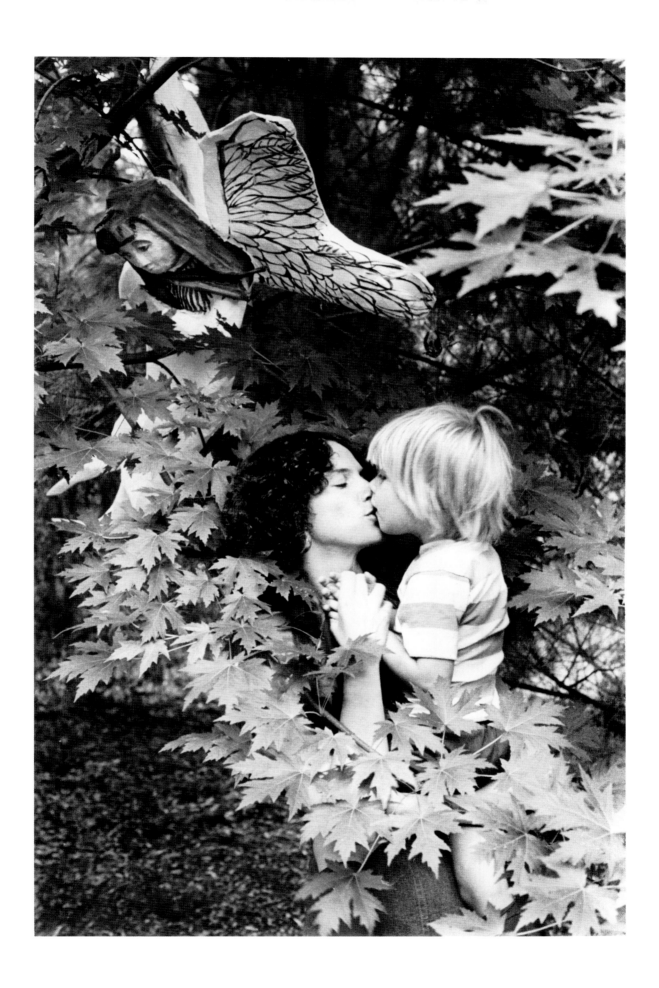

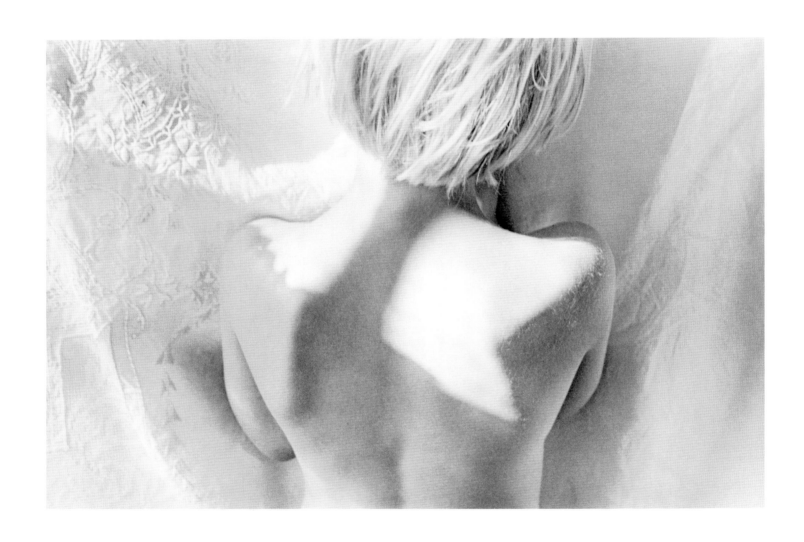

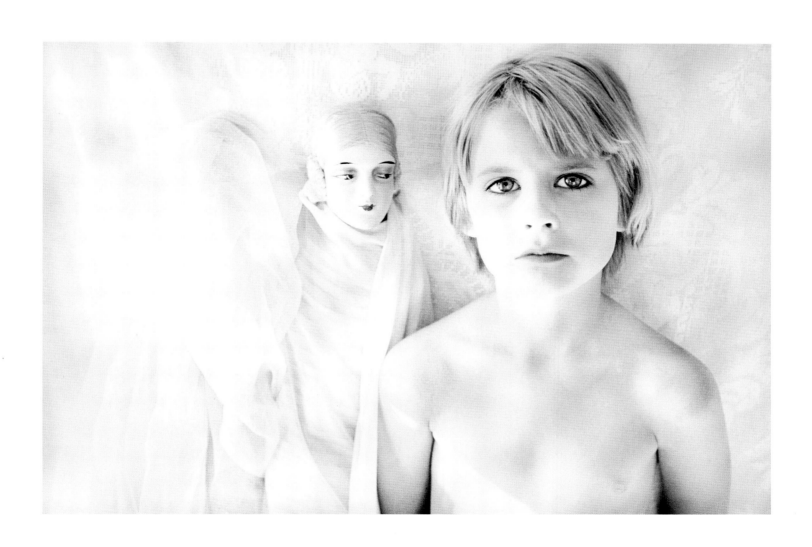

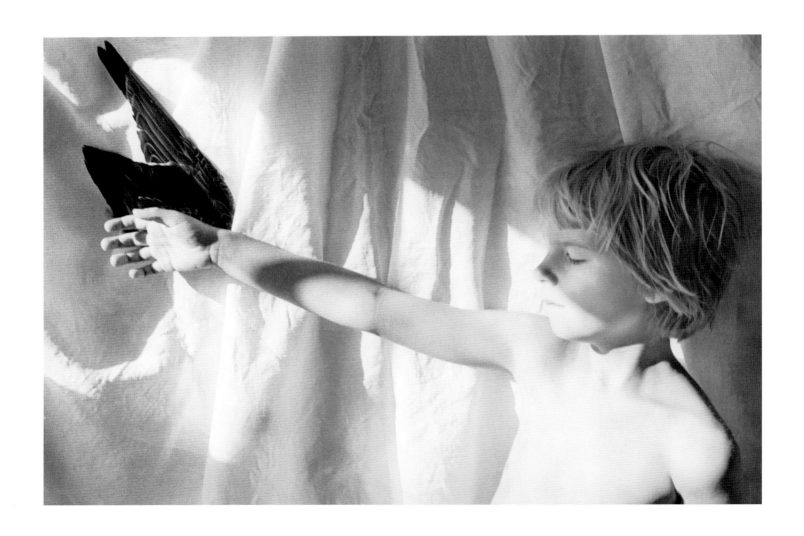

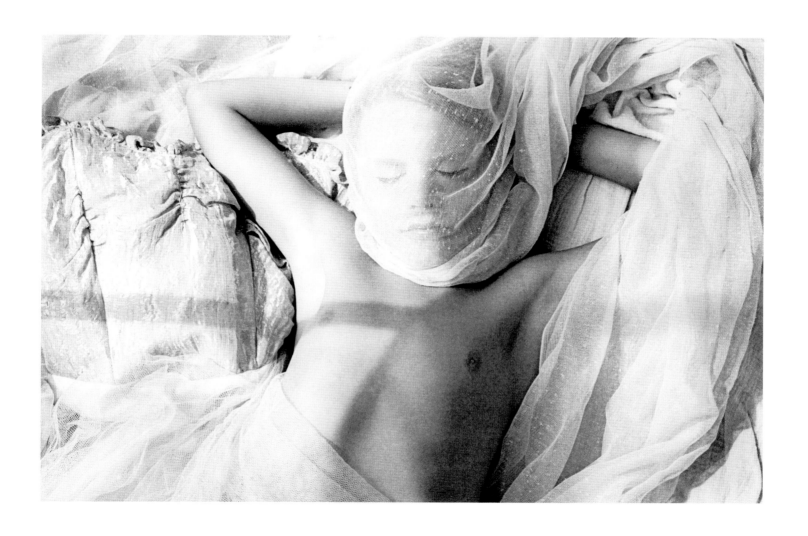

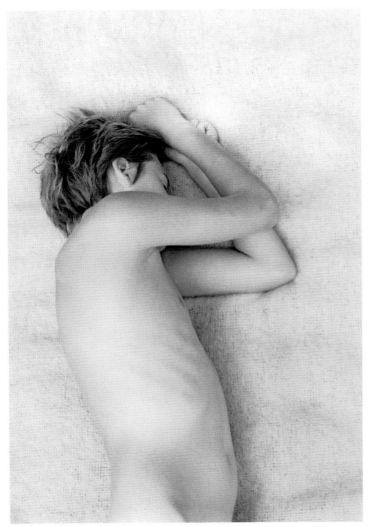
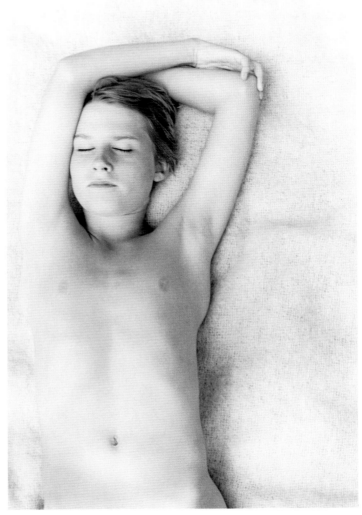

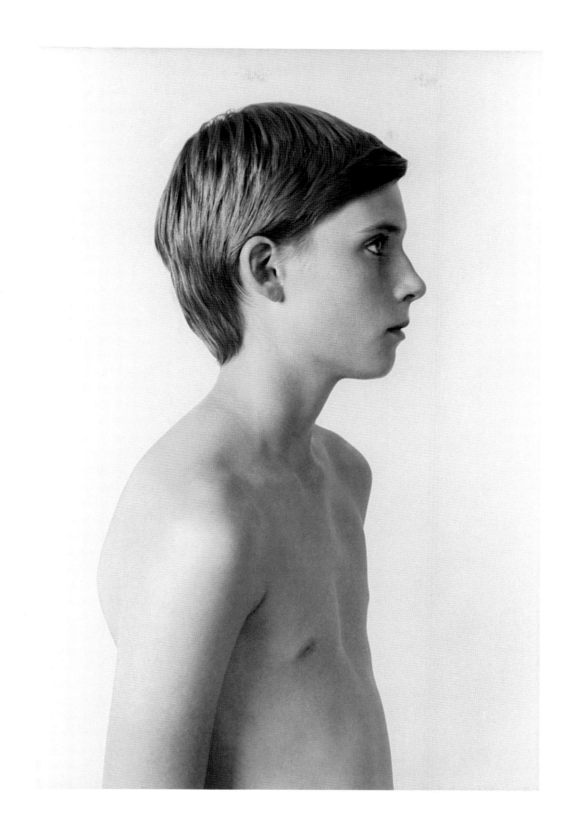

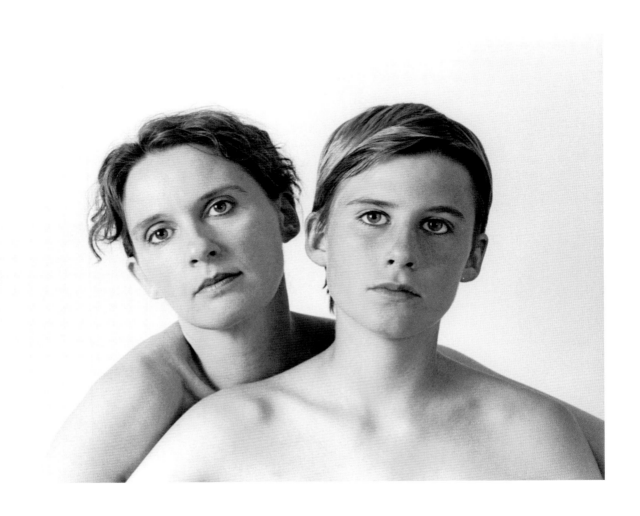

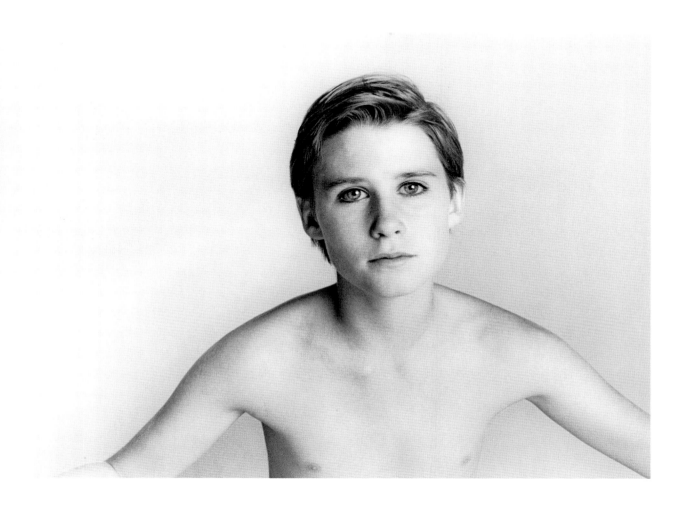

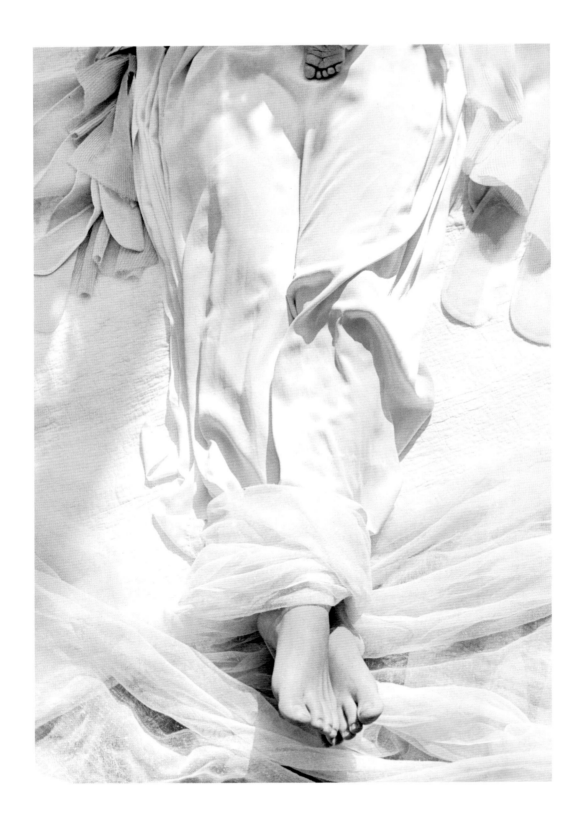

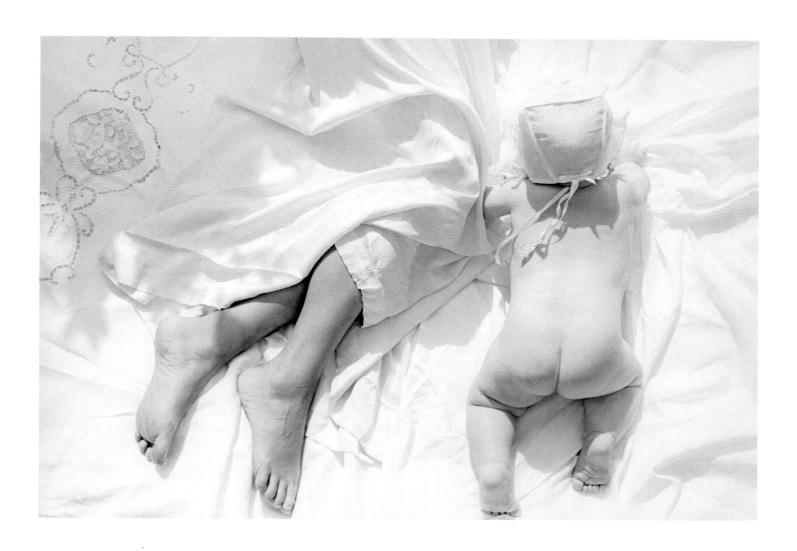

63

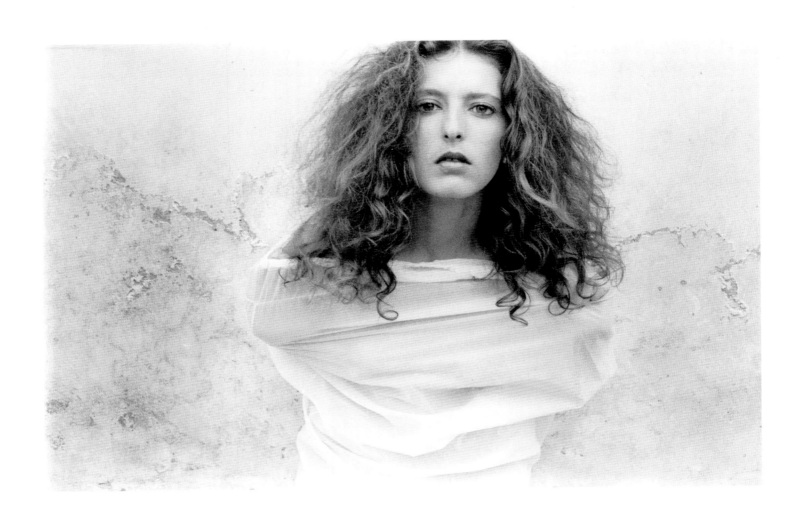

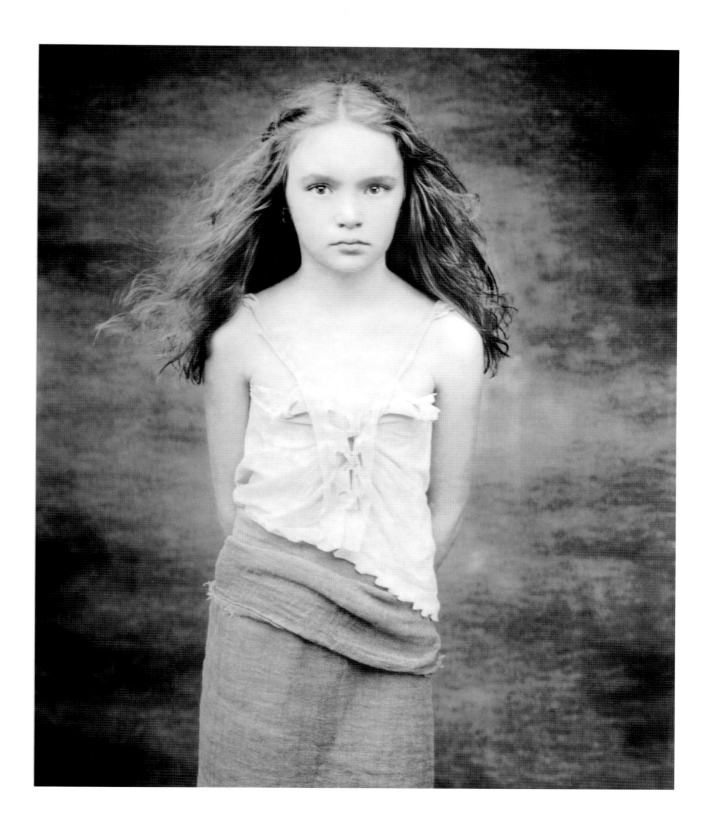

T R A N S F O

R M A T I O N S

"I was exposed early on to the world of the unconscious.

Spirituality and sensuality became

completely interwoven in my psyche."

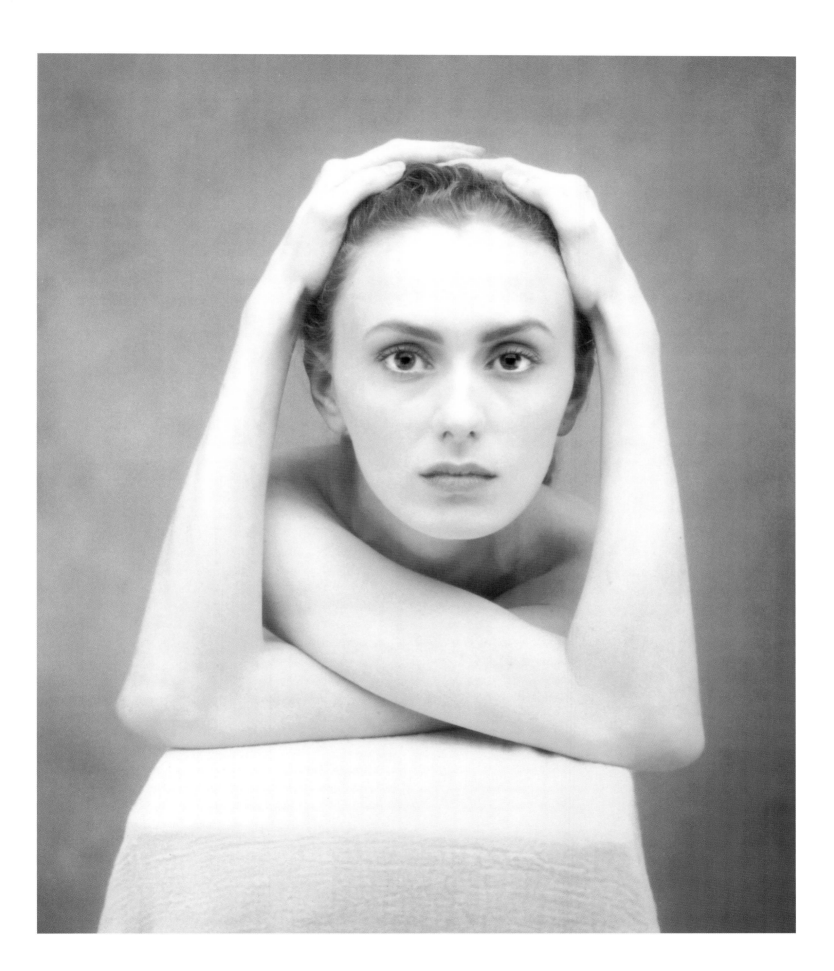

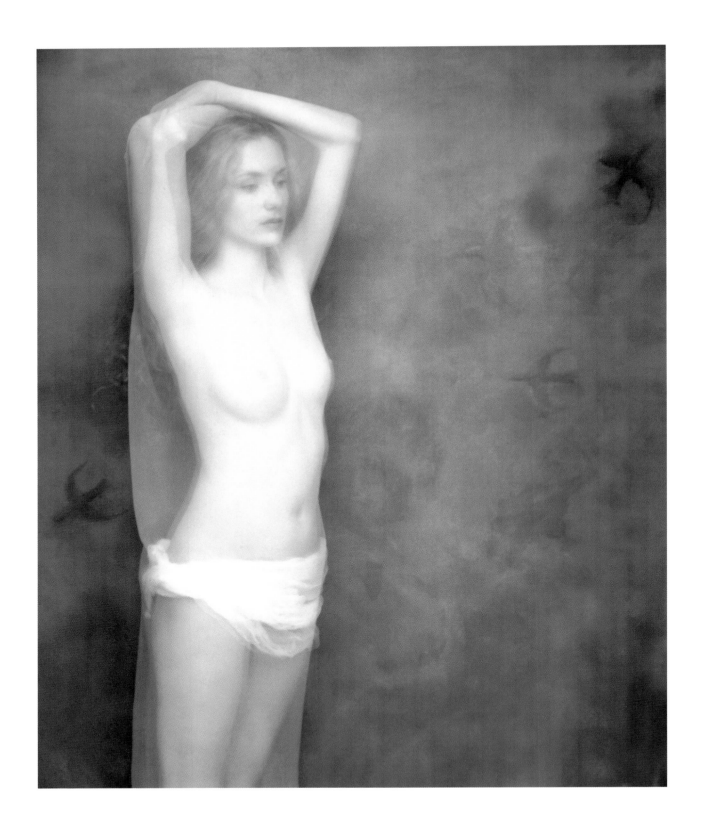

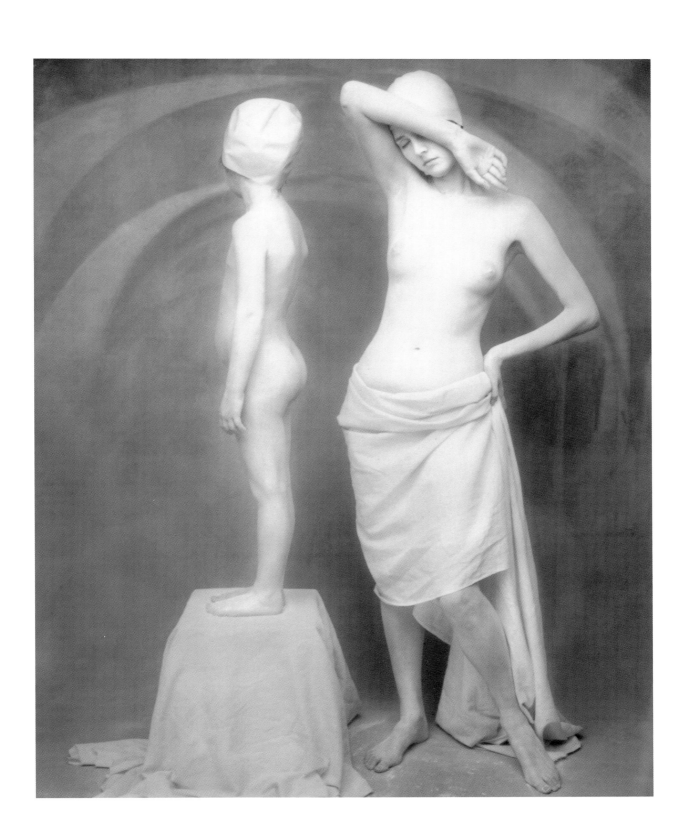

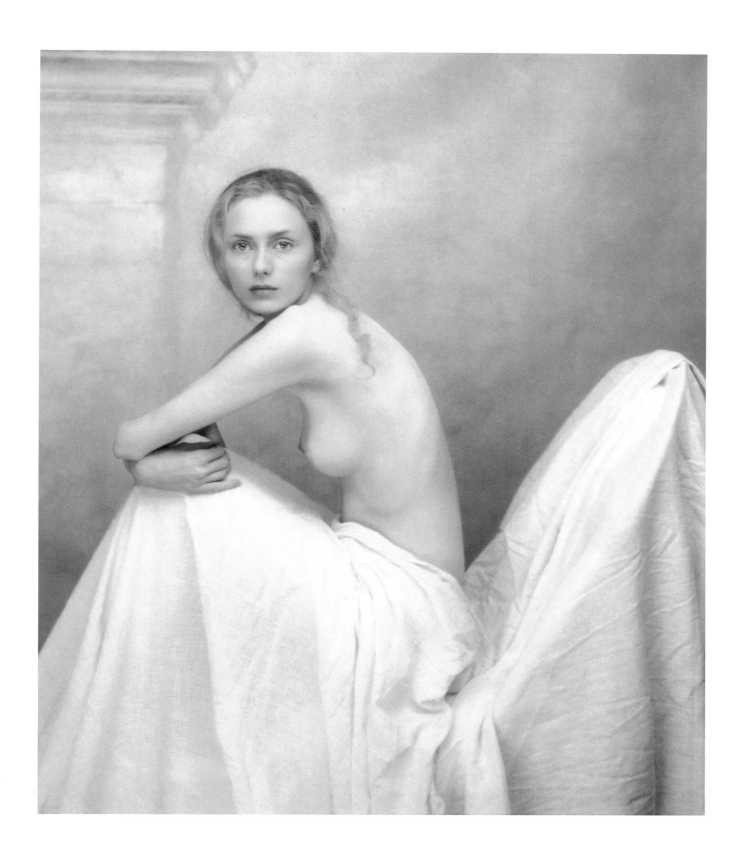

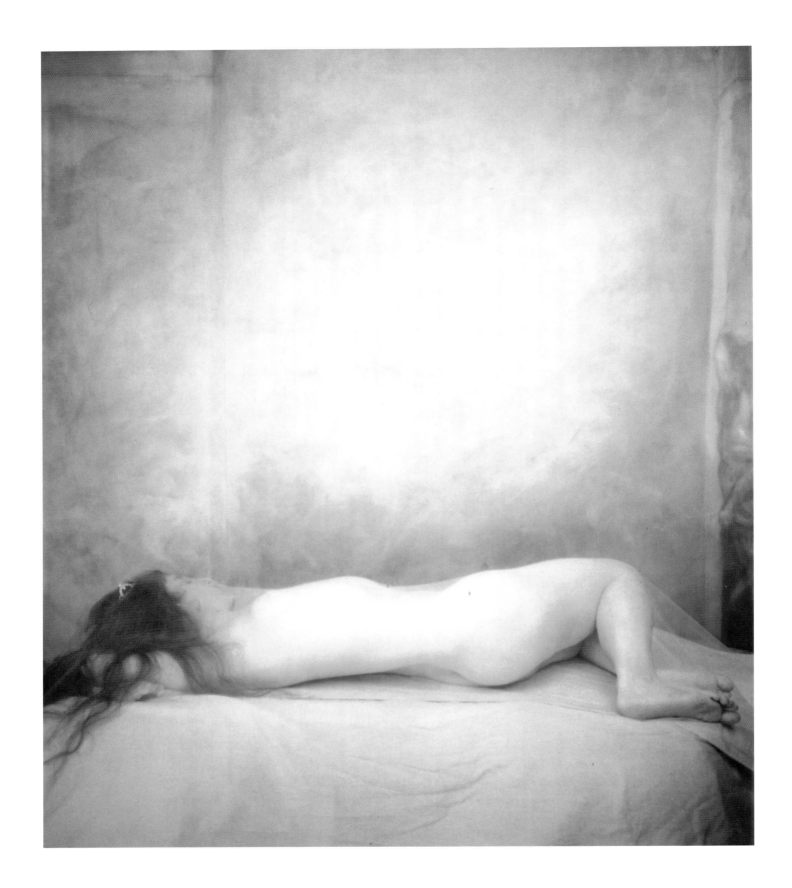

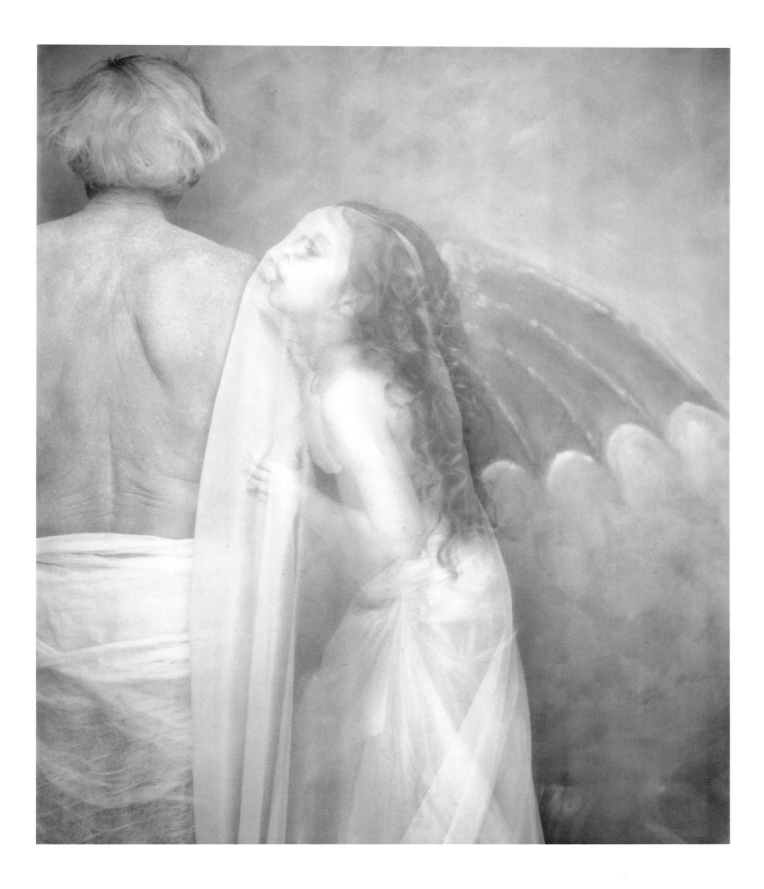

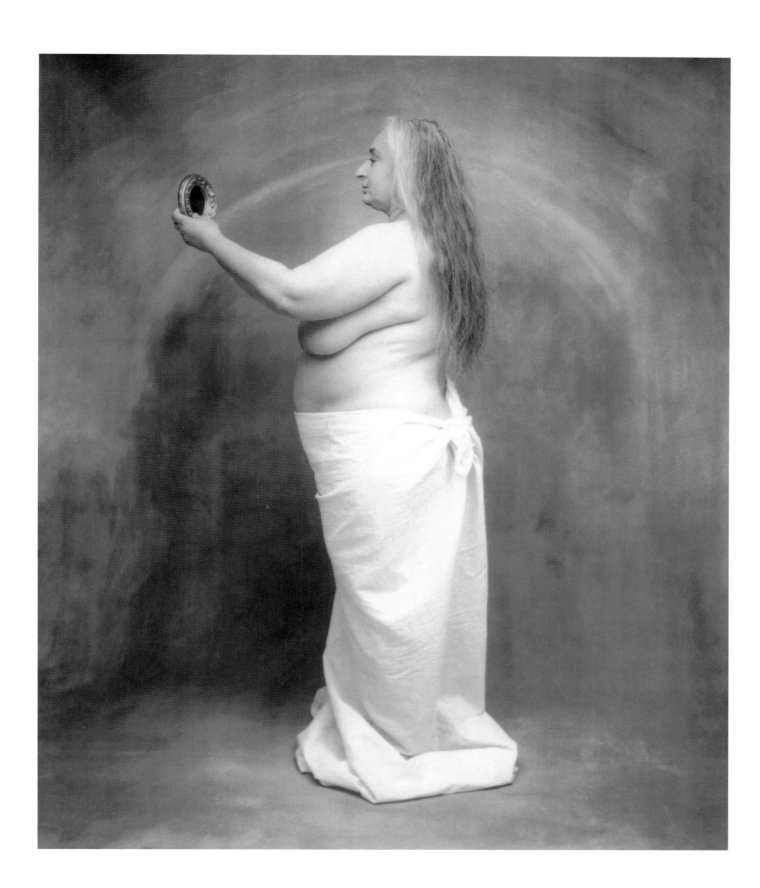

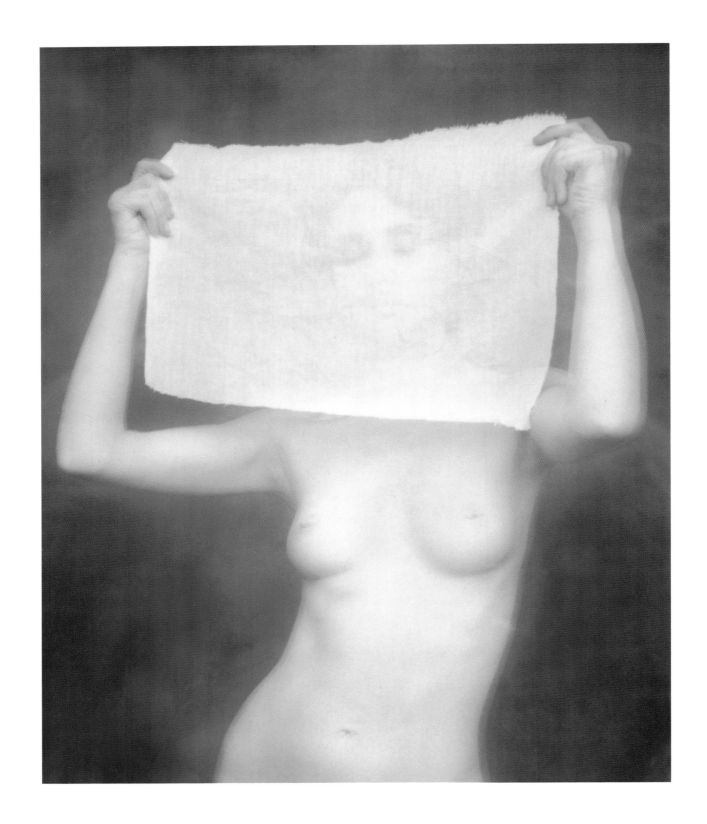

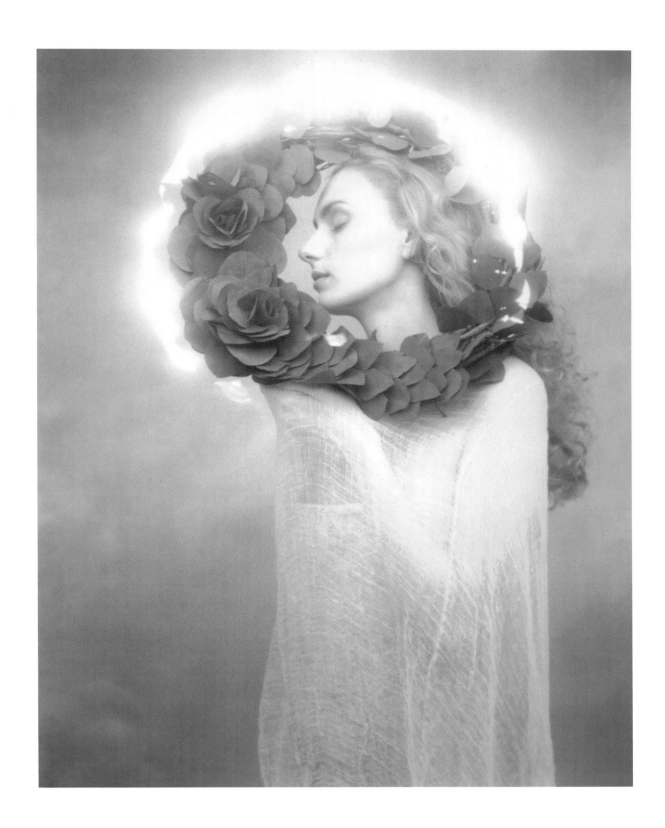

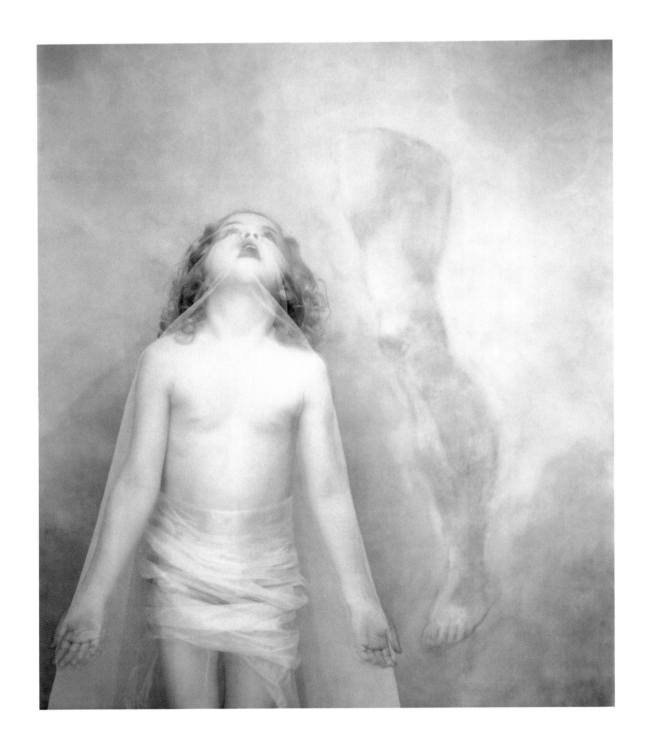

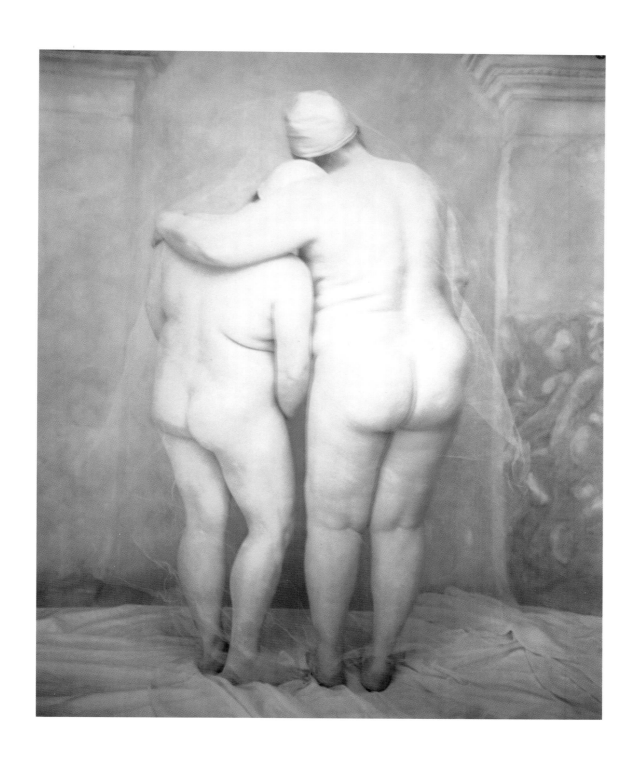

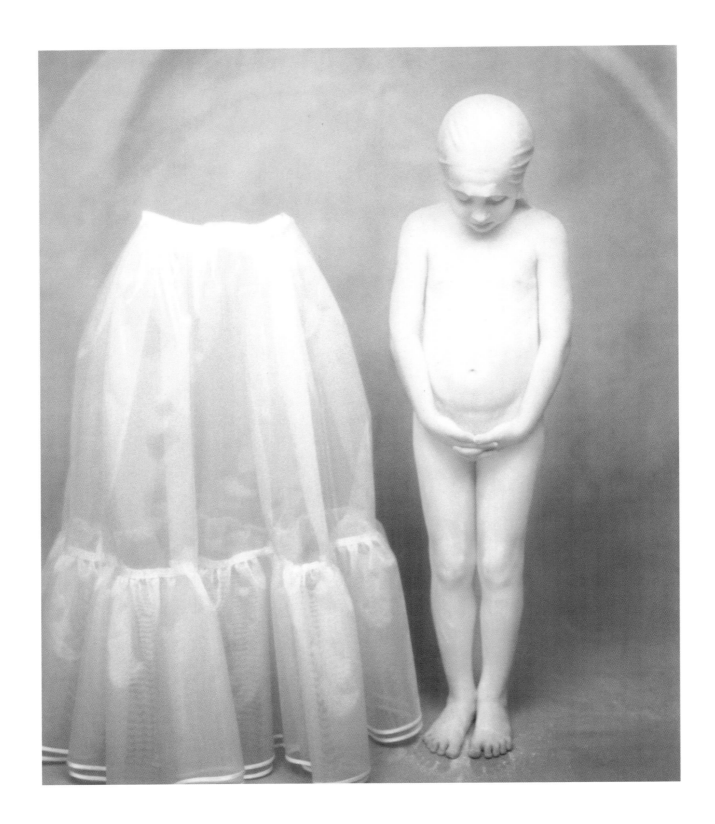

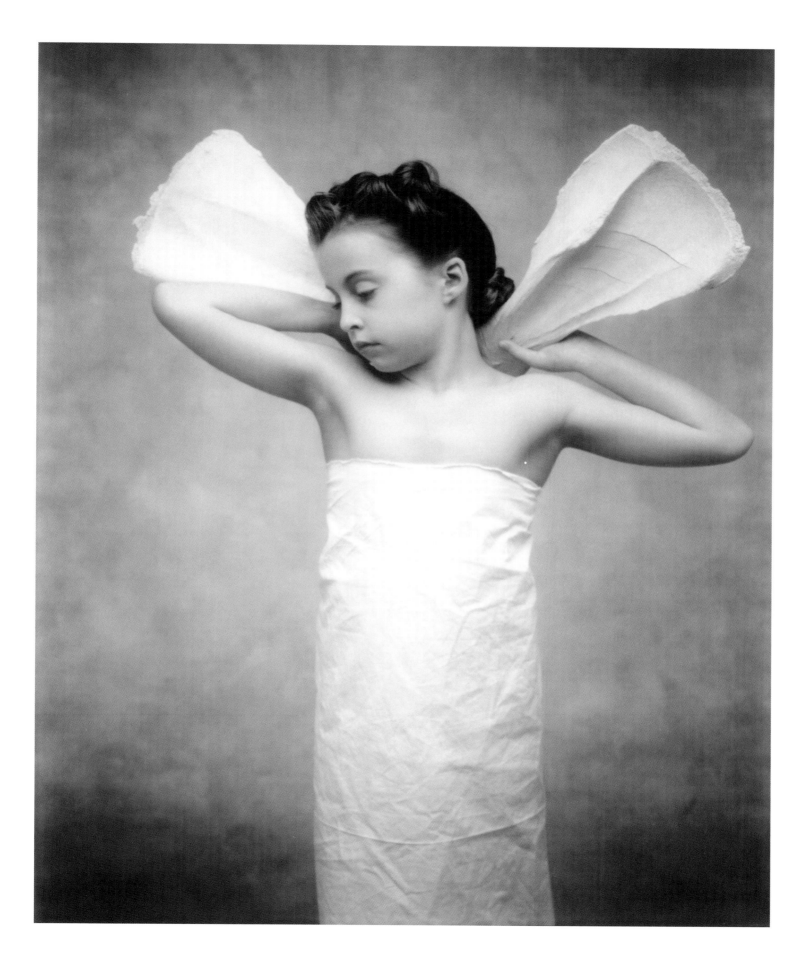

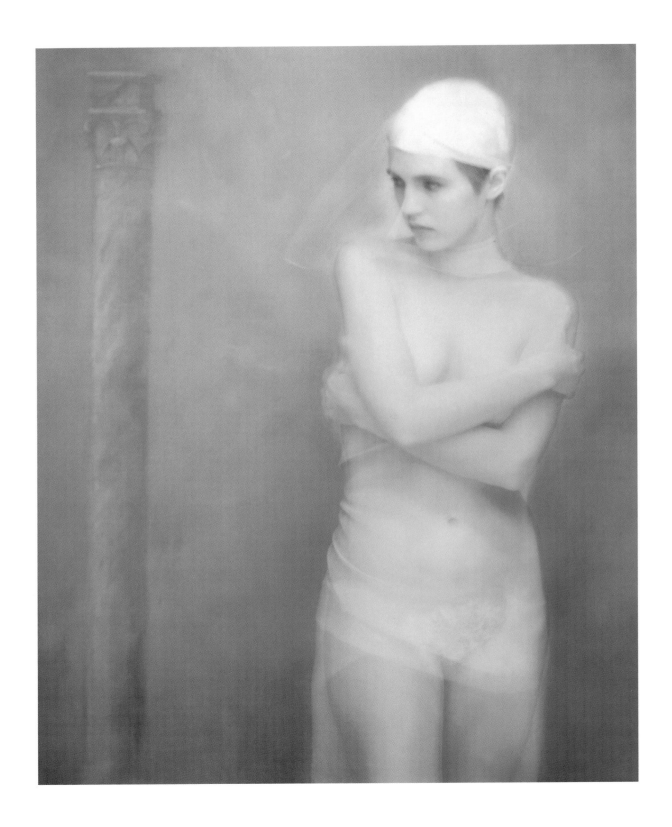

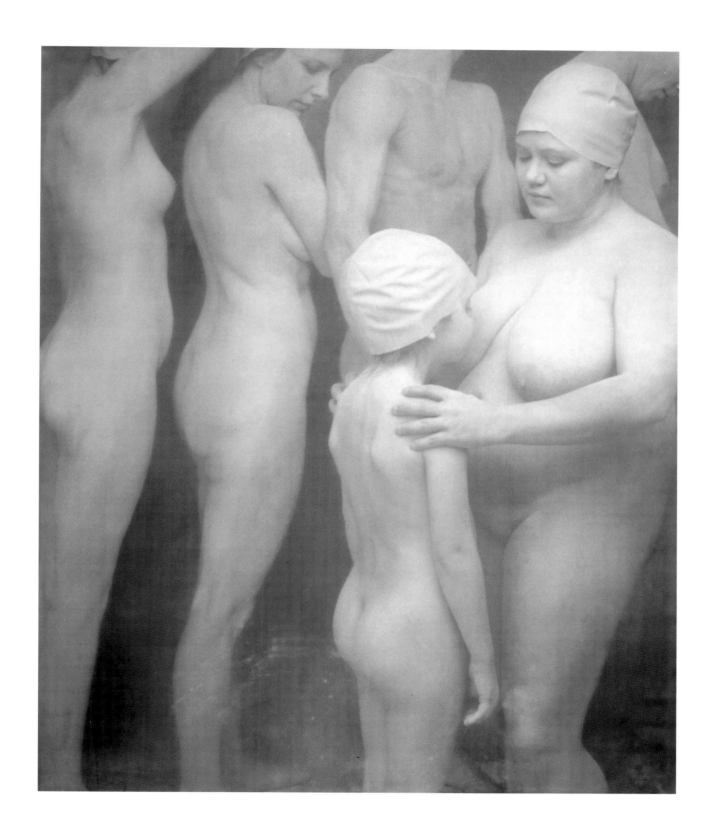

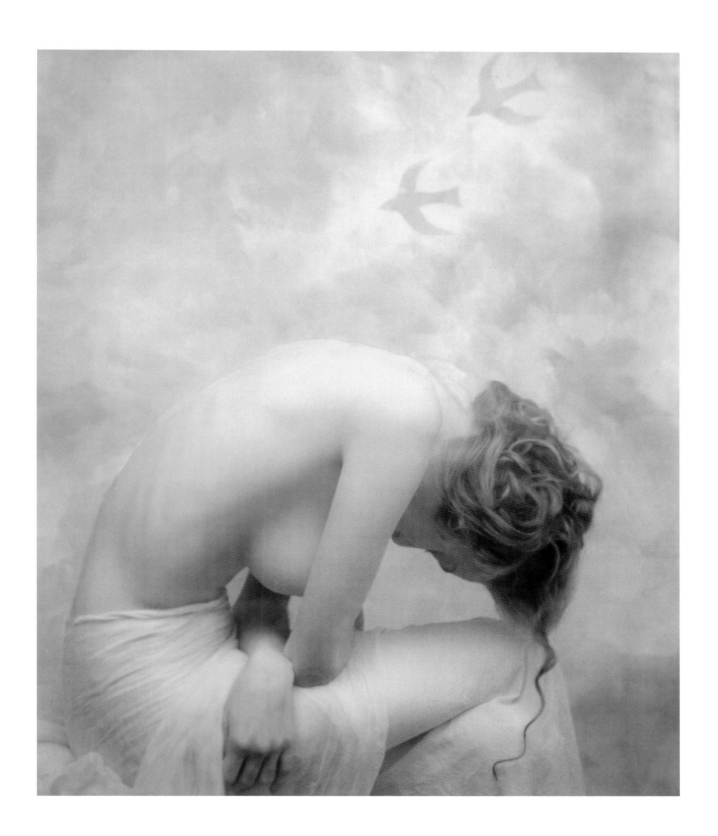

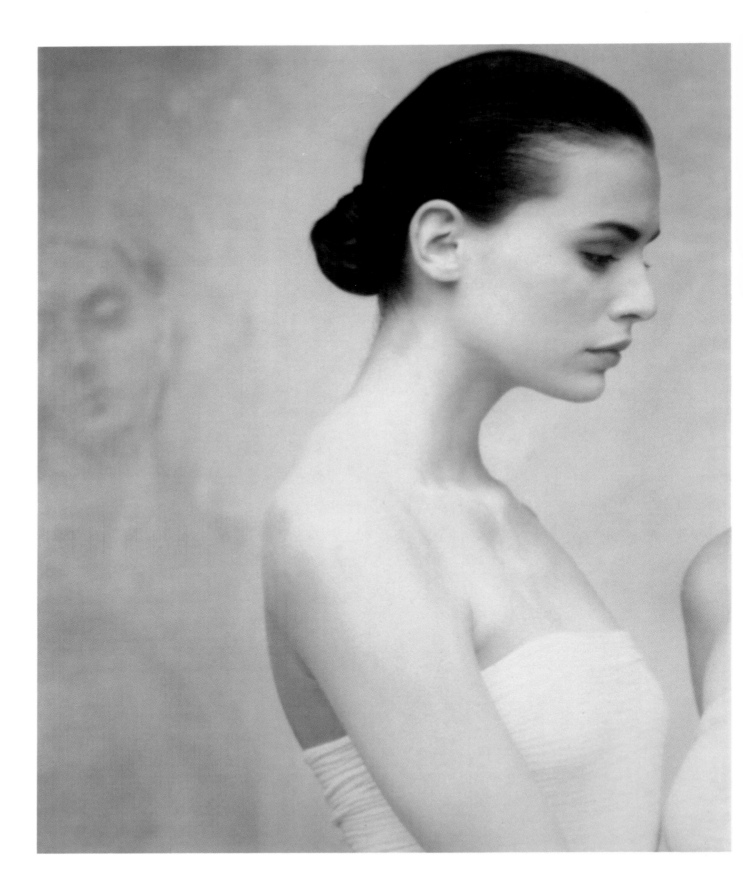

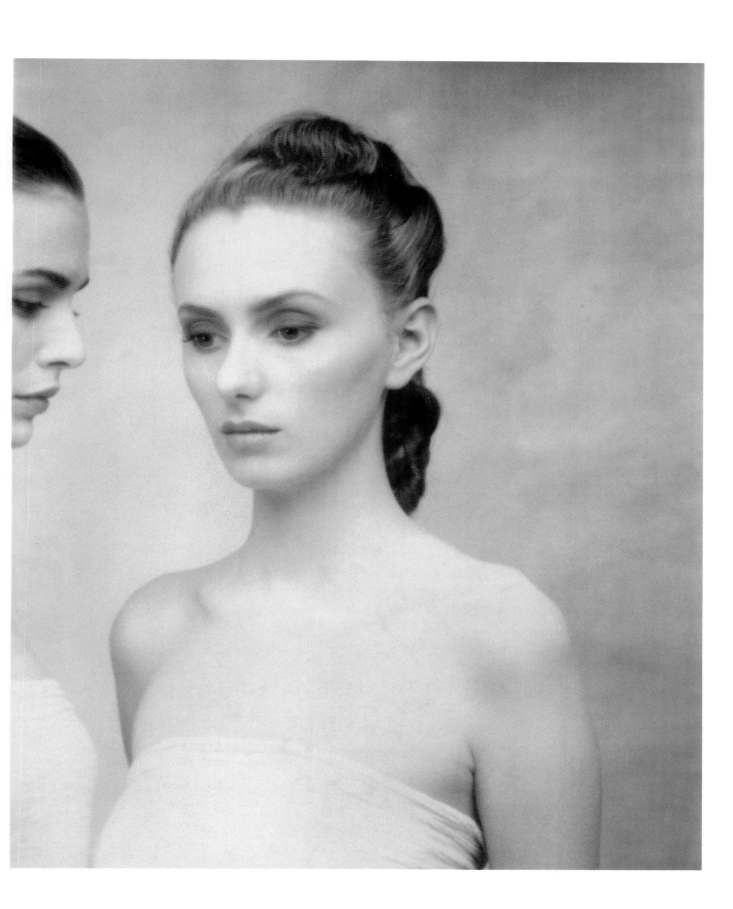

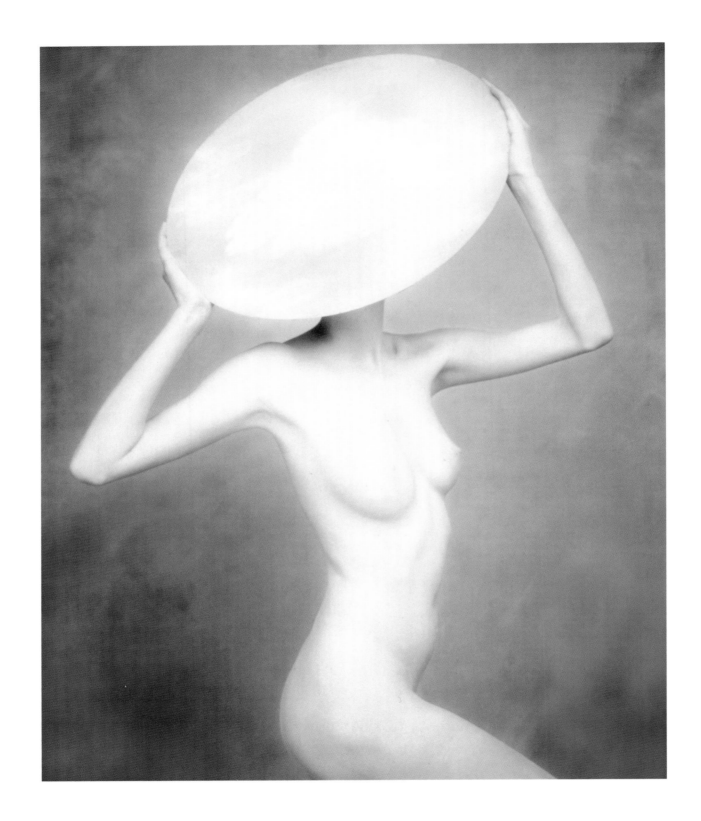

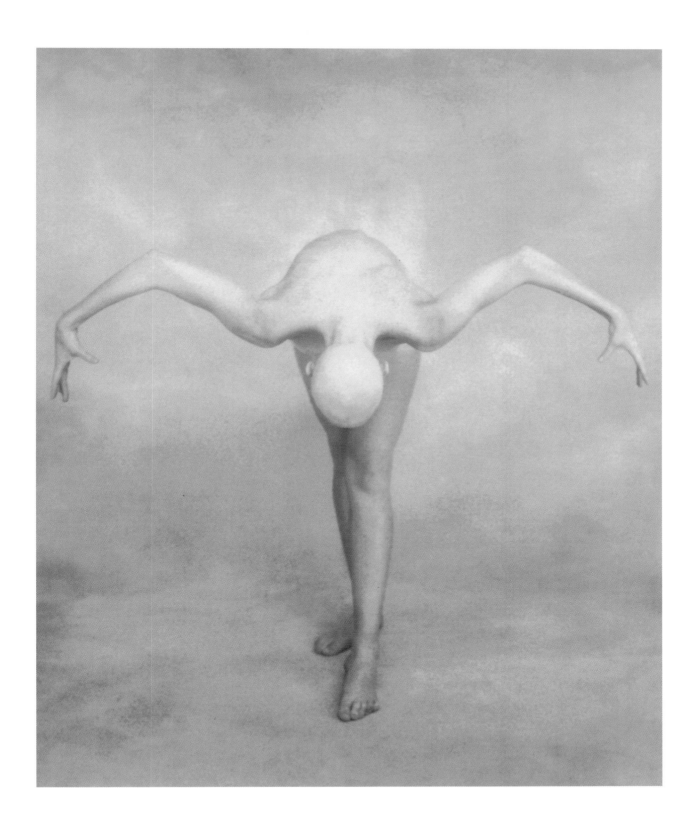

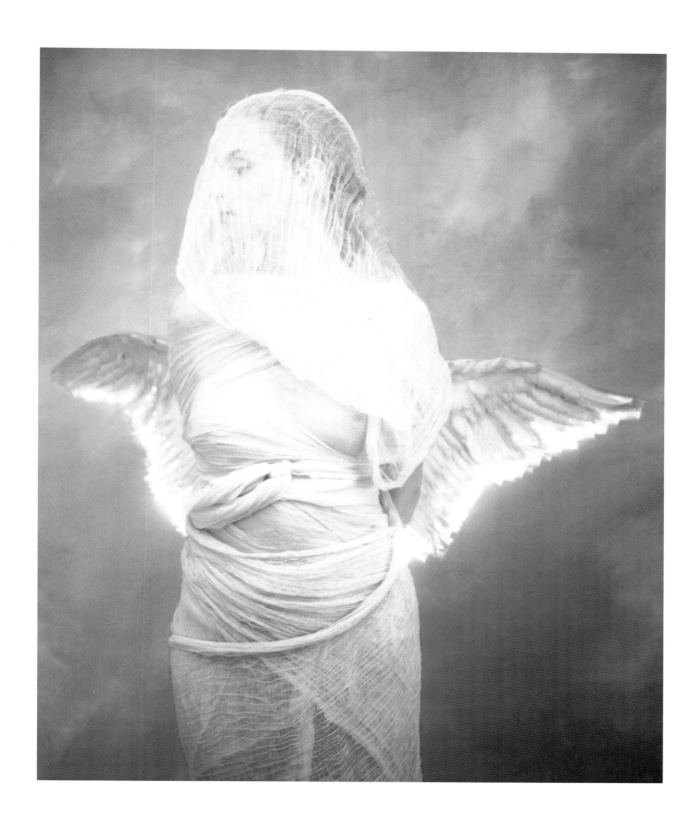

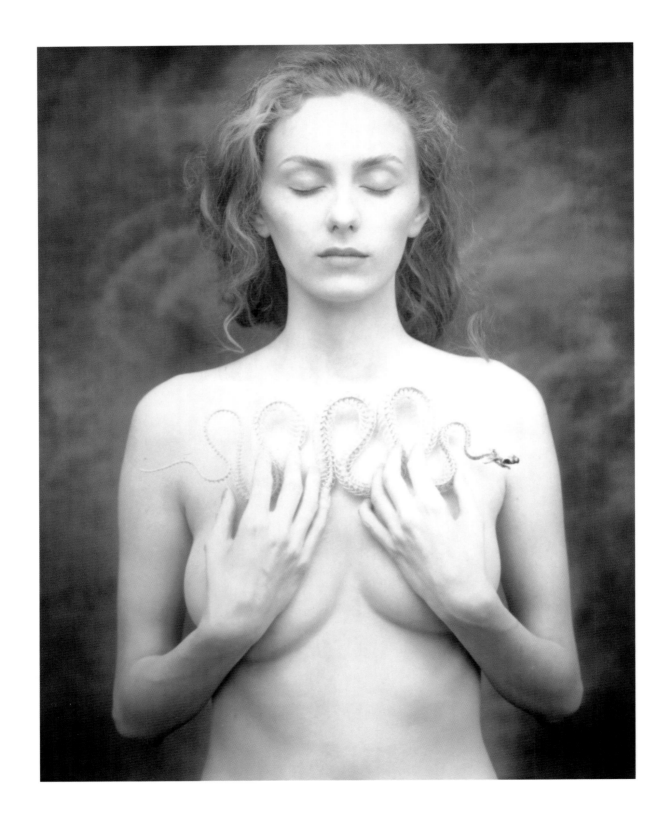

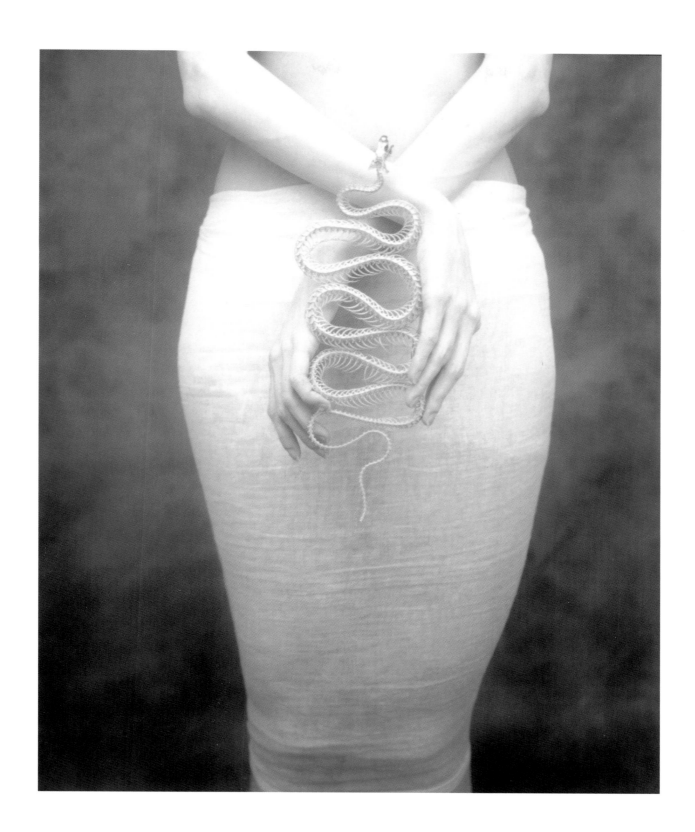

L I G H T

WARRIORS

"In ancient times, women from many cultures

taught the Earth's mysteries and provided the light

of awareness and wholeness in the family. They were leaders.

I believe we still have these gifts."

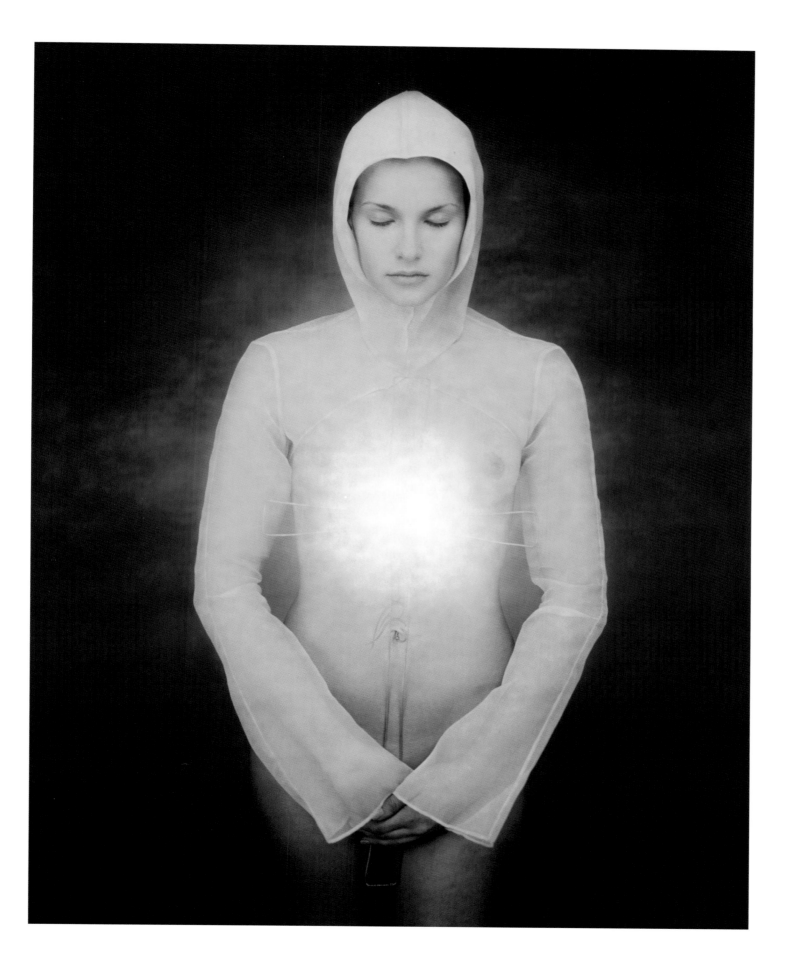

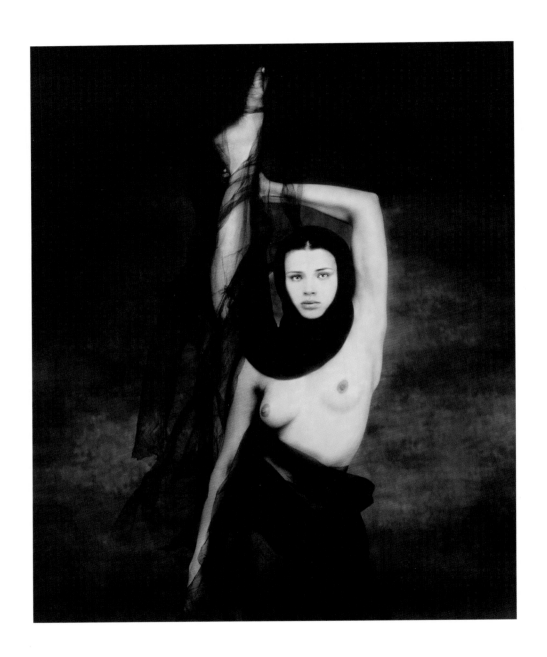

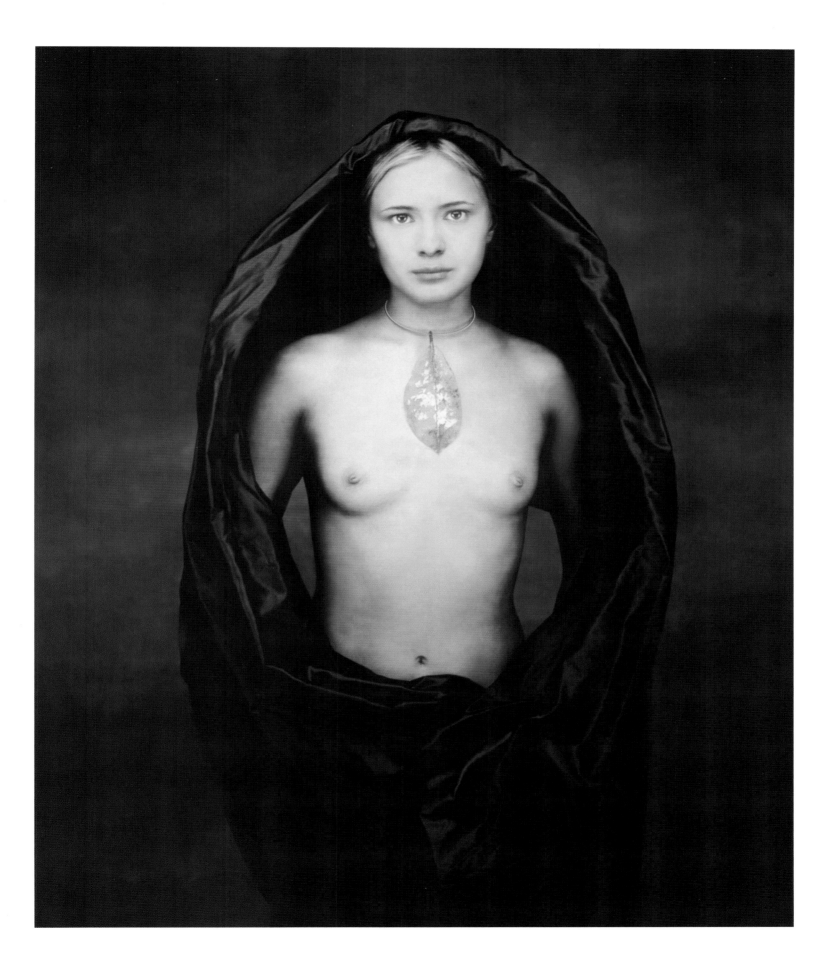

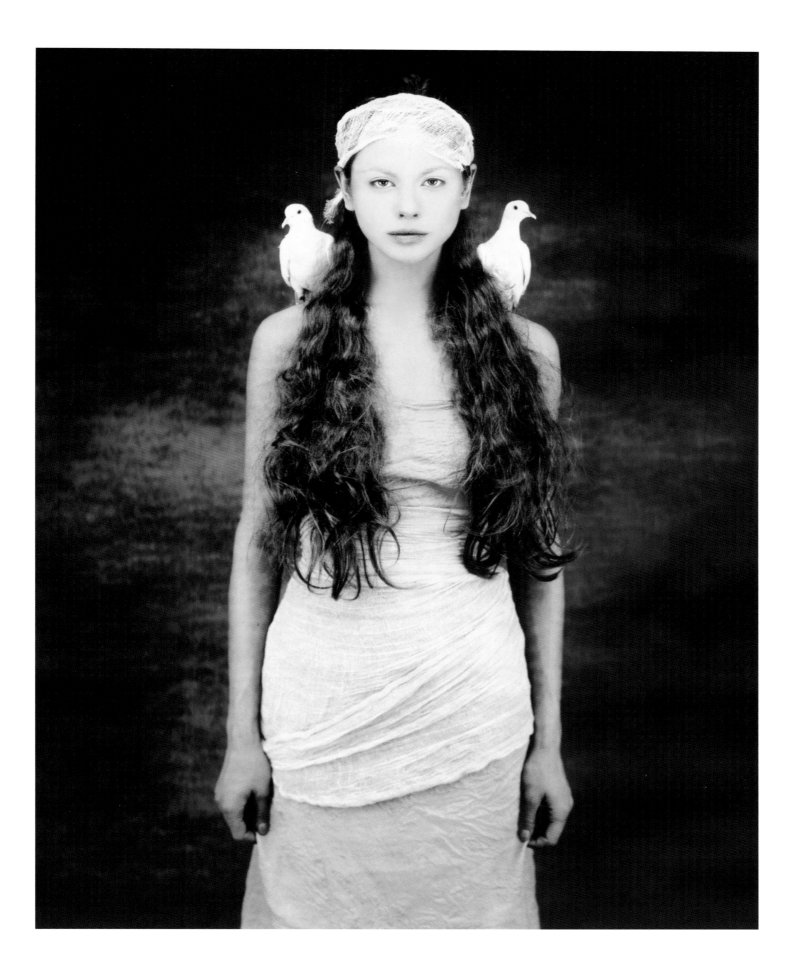

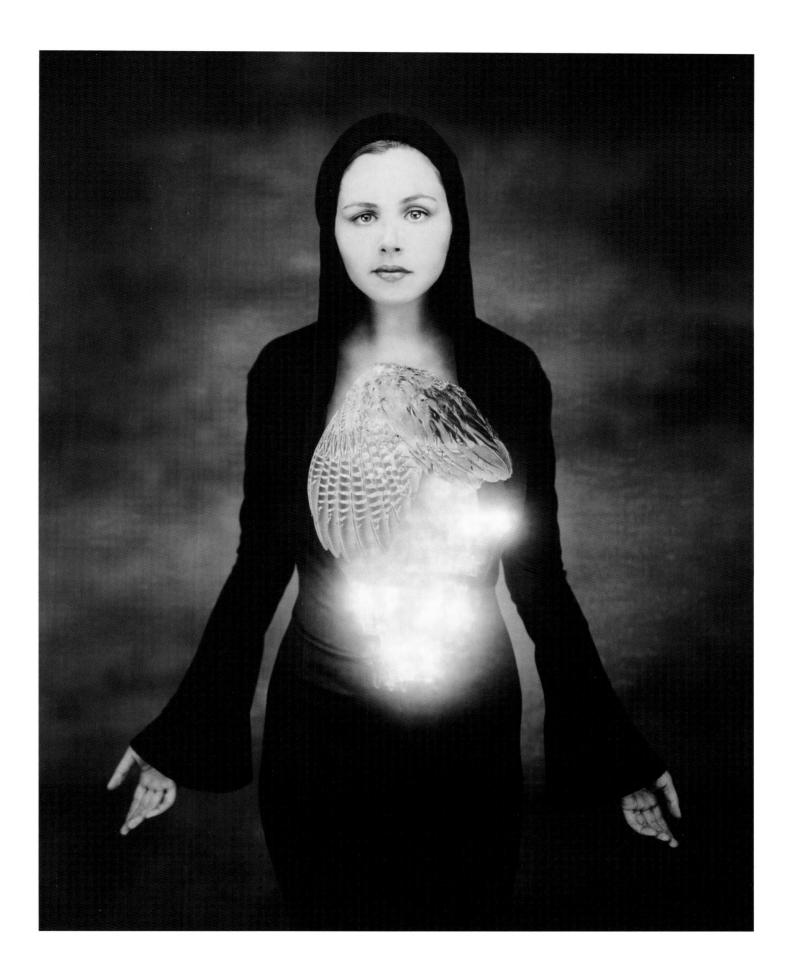

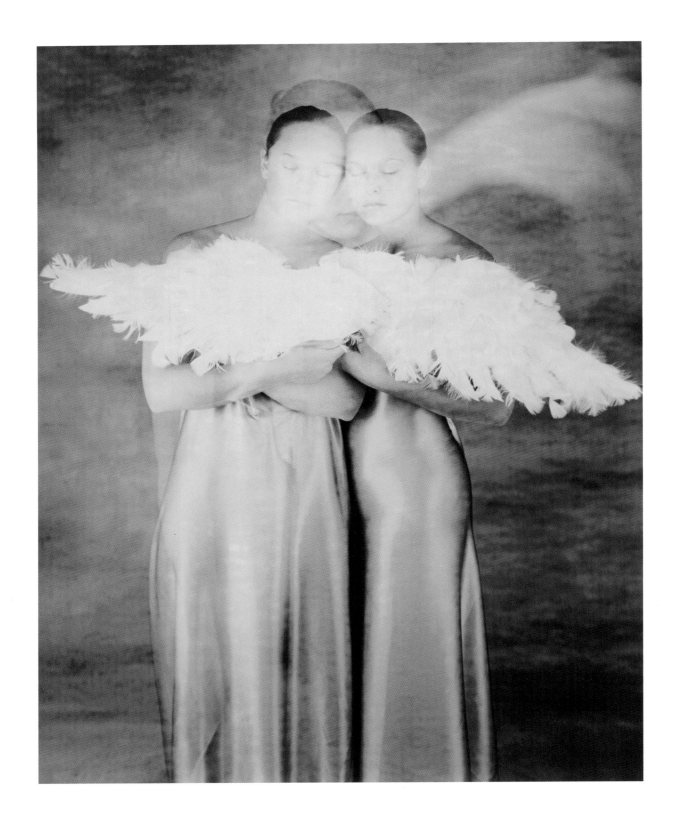

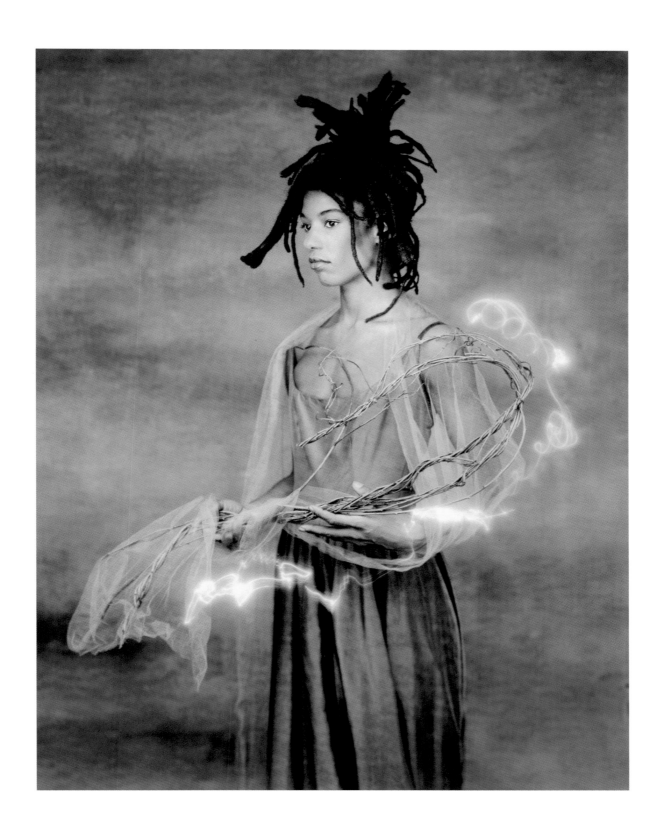

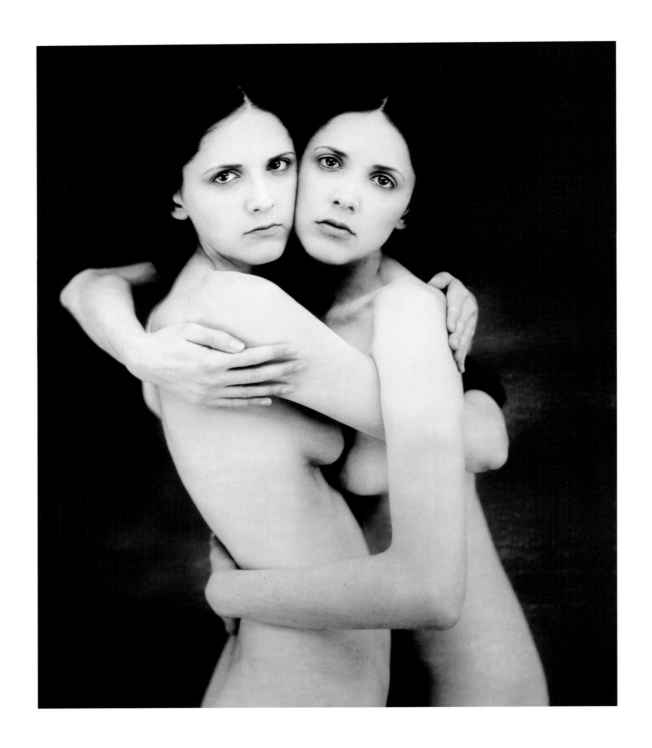

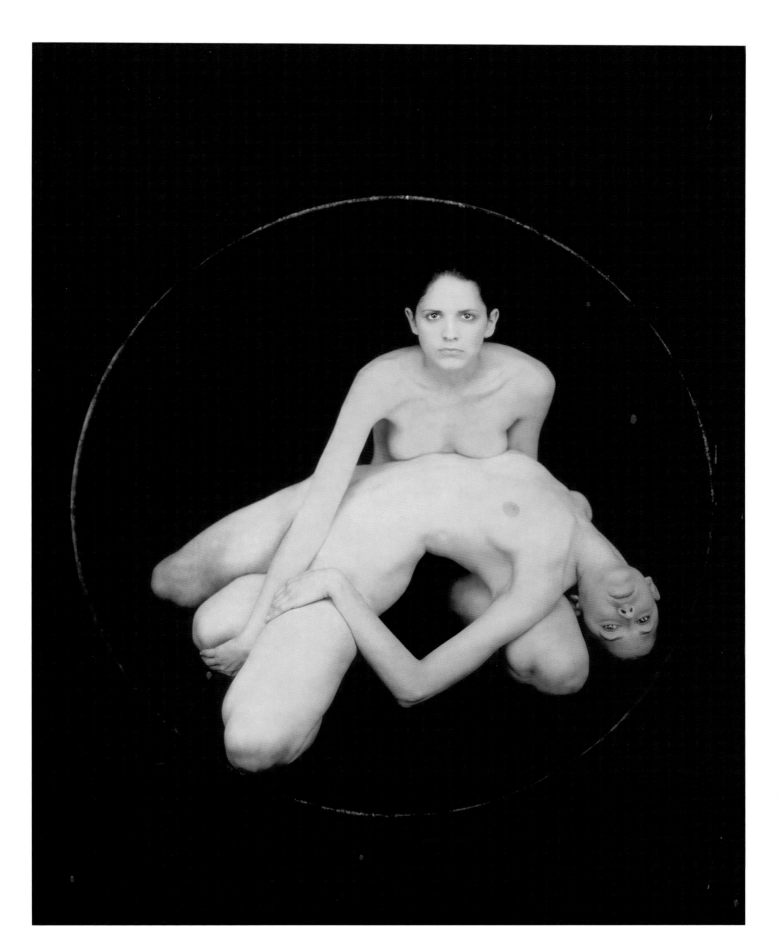

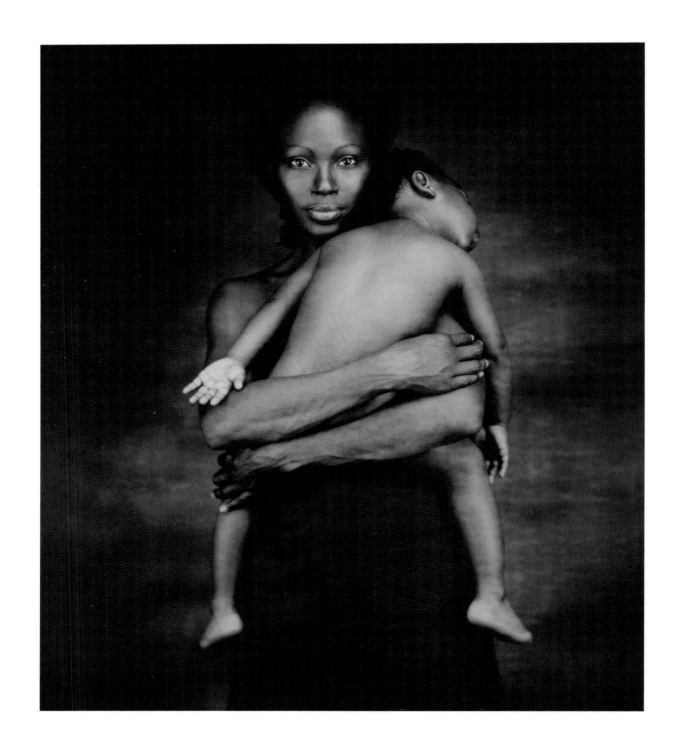

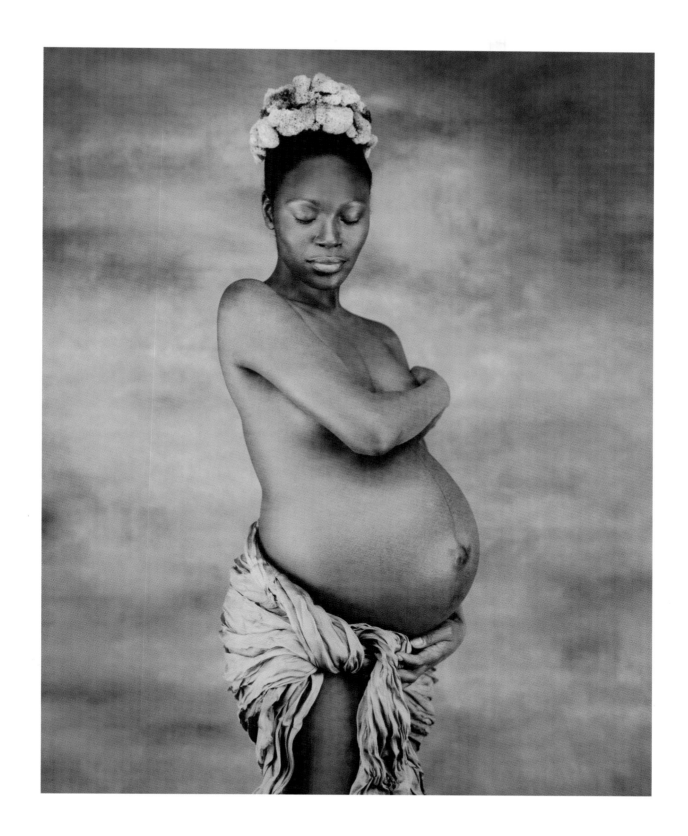

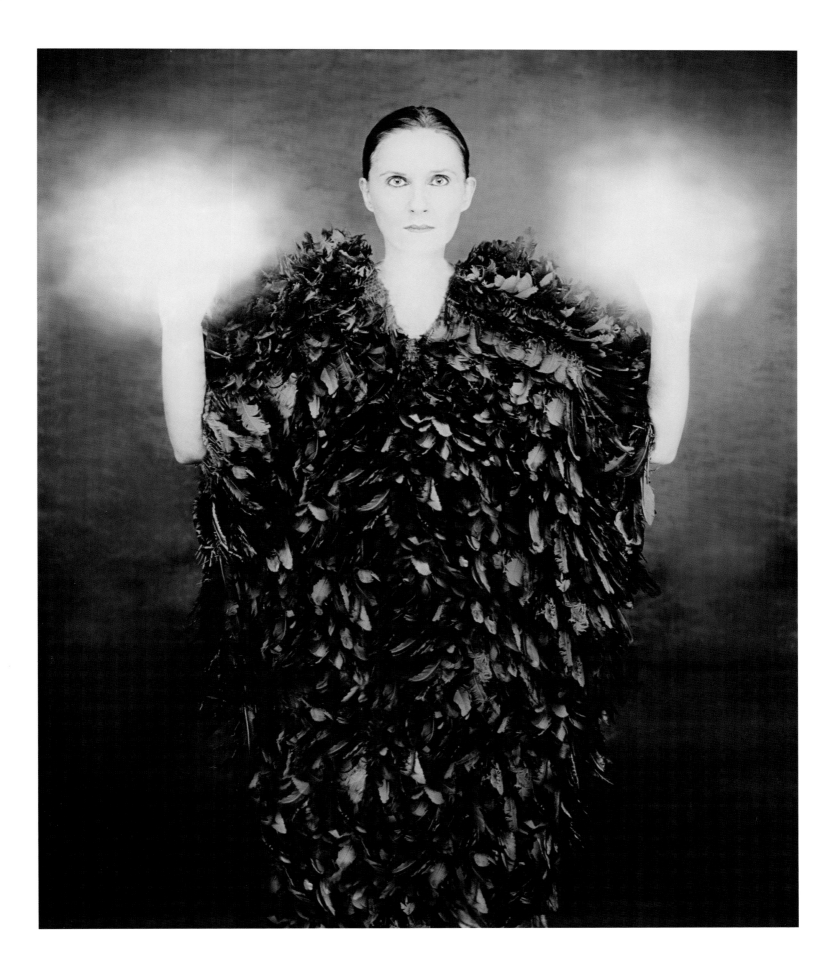

WISE

W O M E N

"A true portrait can never hide the inner life of its subject.

It is interesting that in our culture we hide and cover the body,

yet our faces are naked. Through a person's face we can potentially

see everything — the history and depth of that person's life

as well as their connection to an even deeper universal presence."

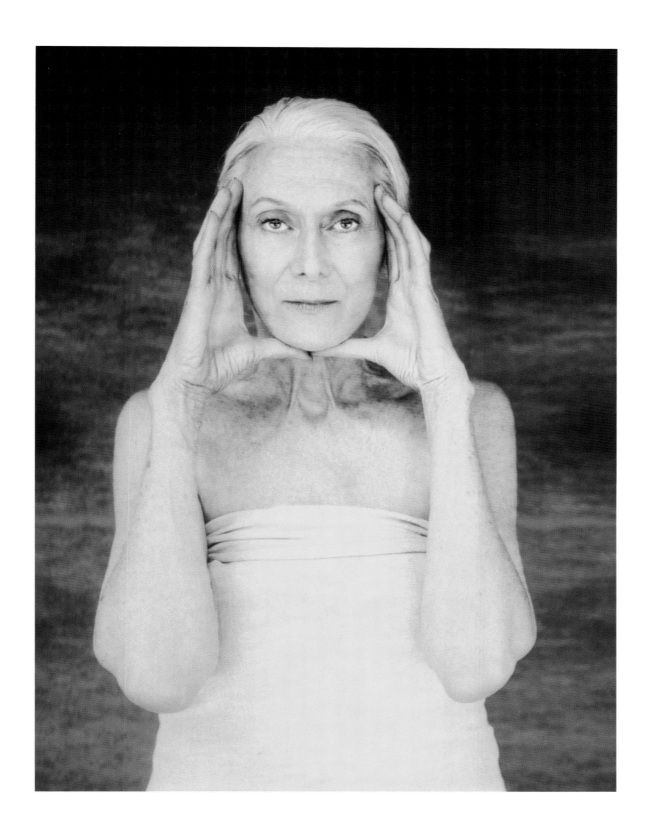

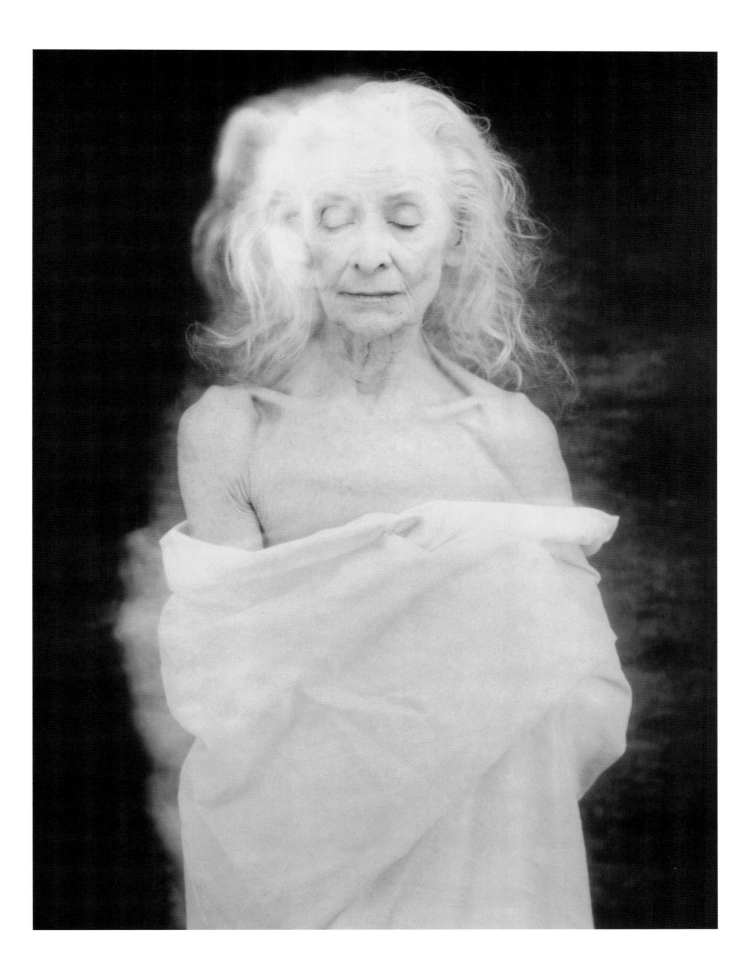

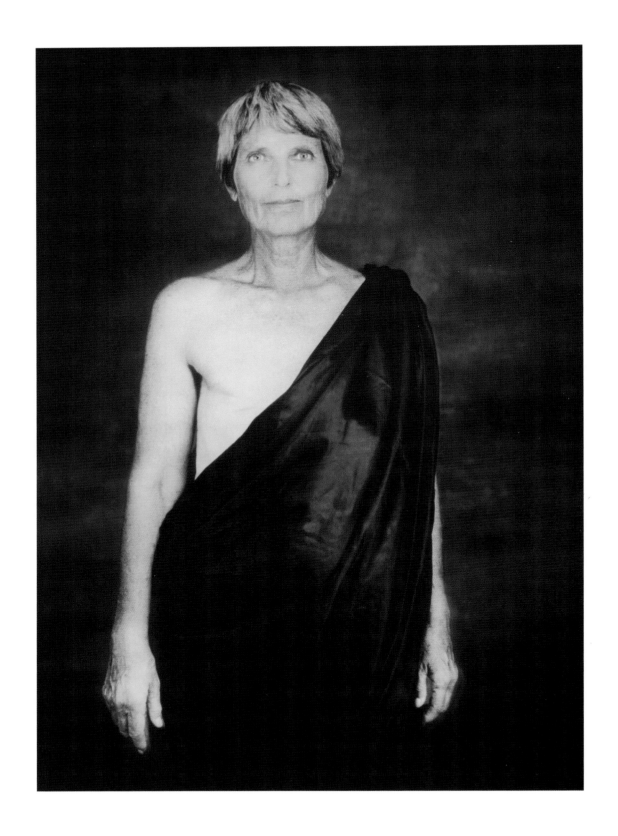

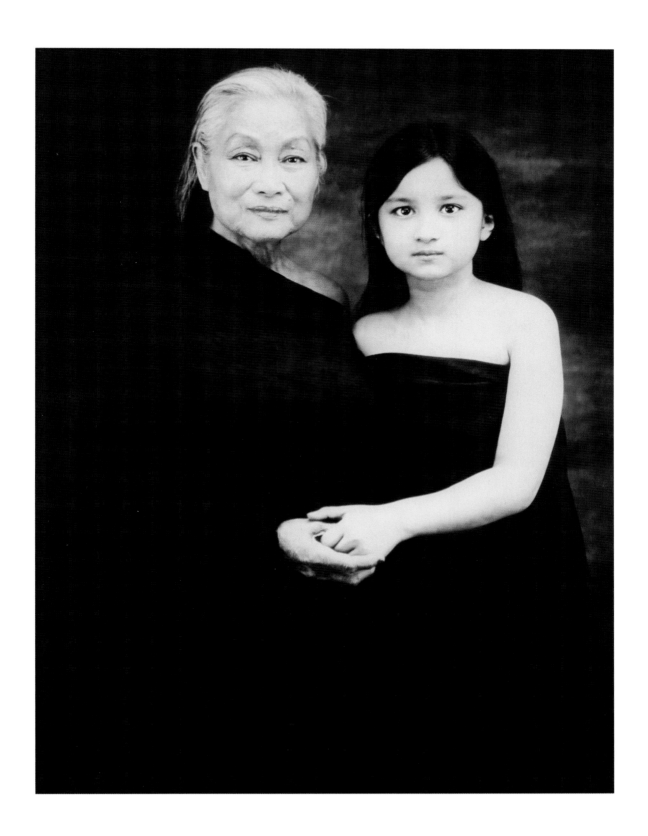

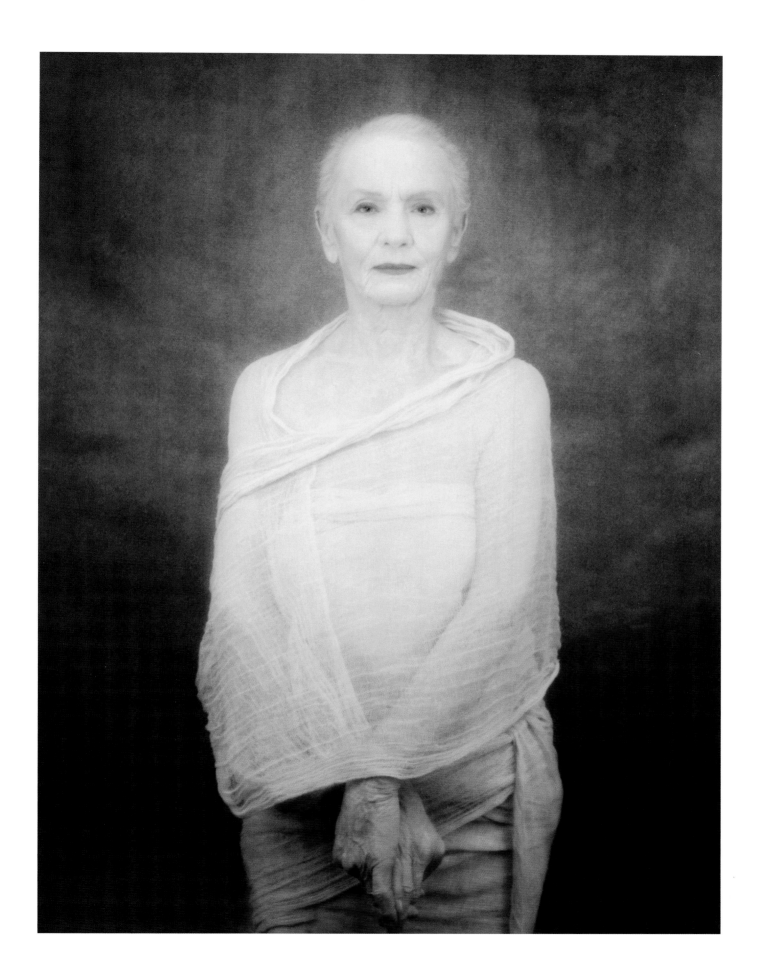

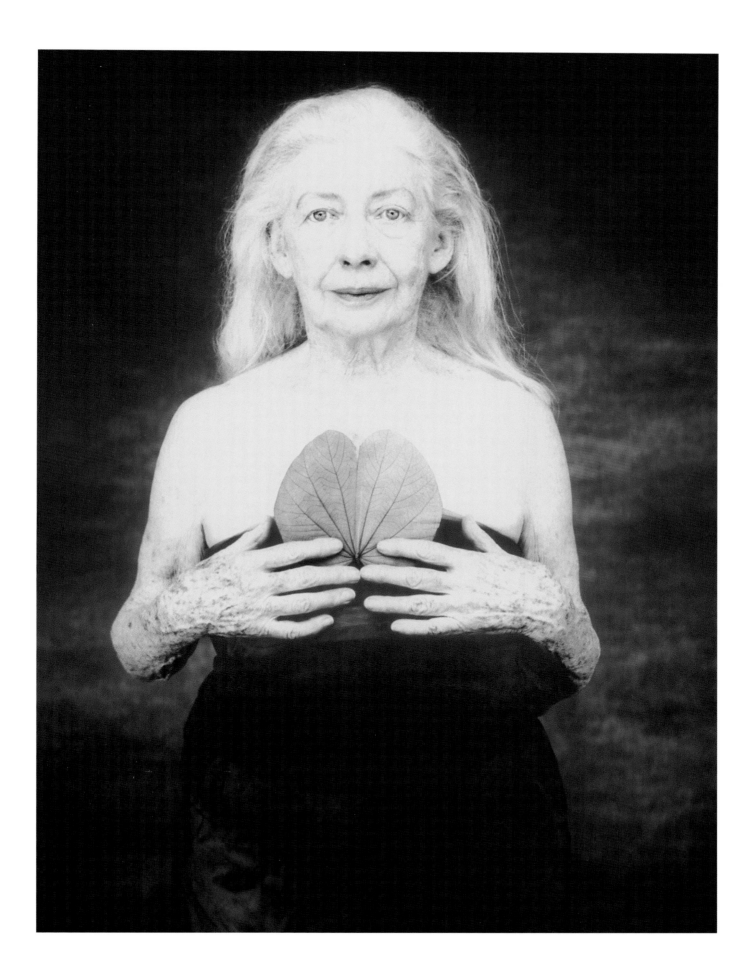

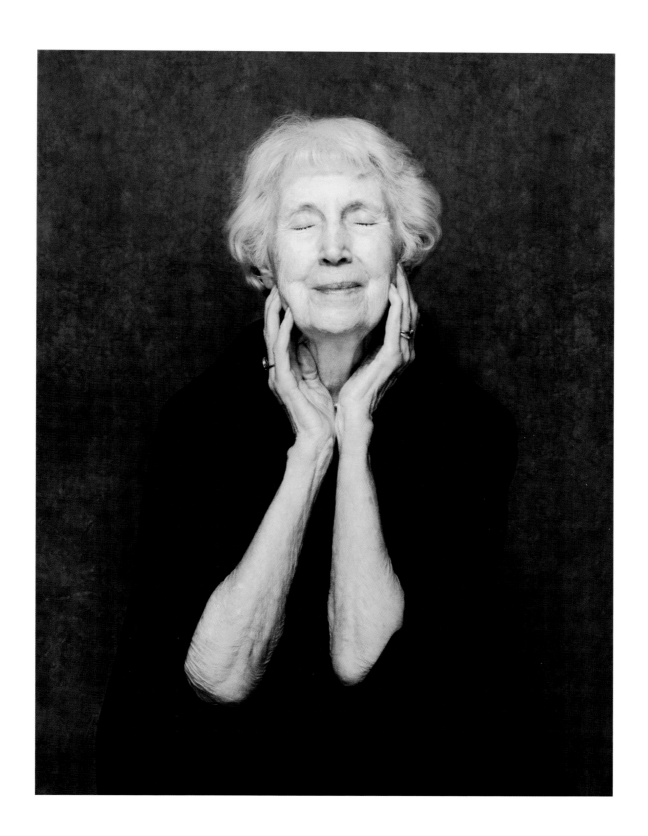

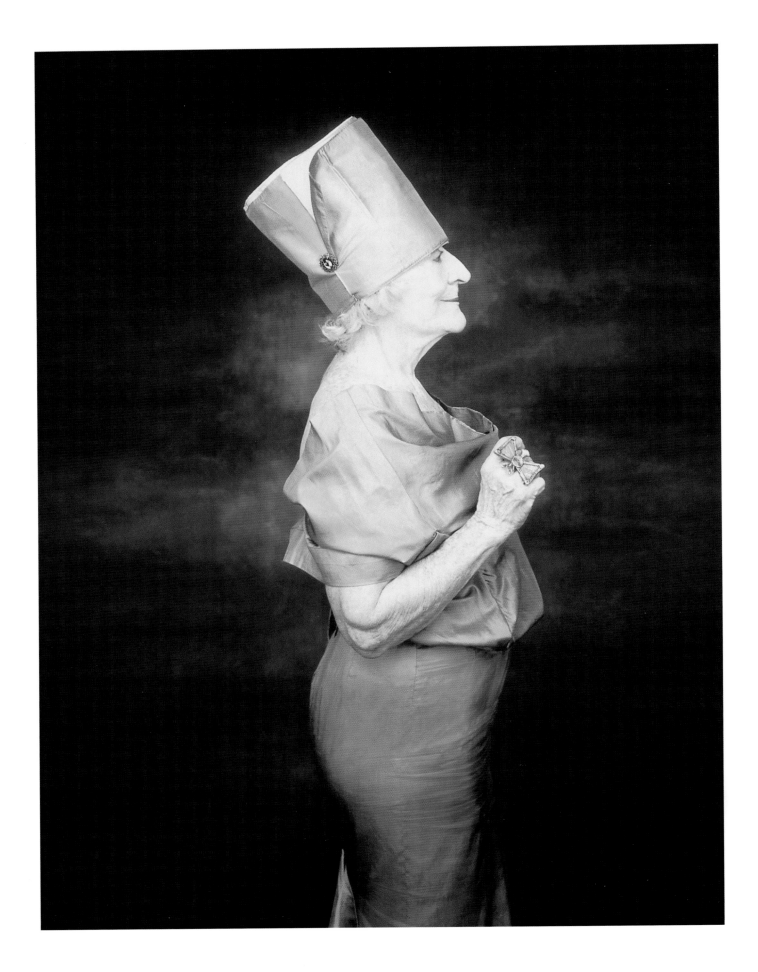

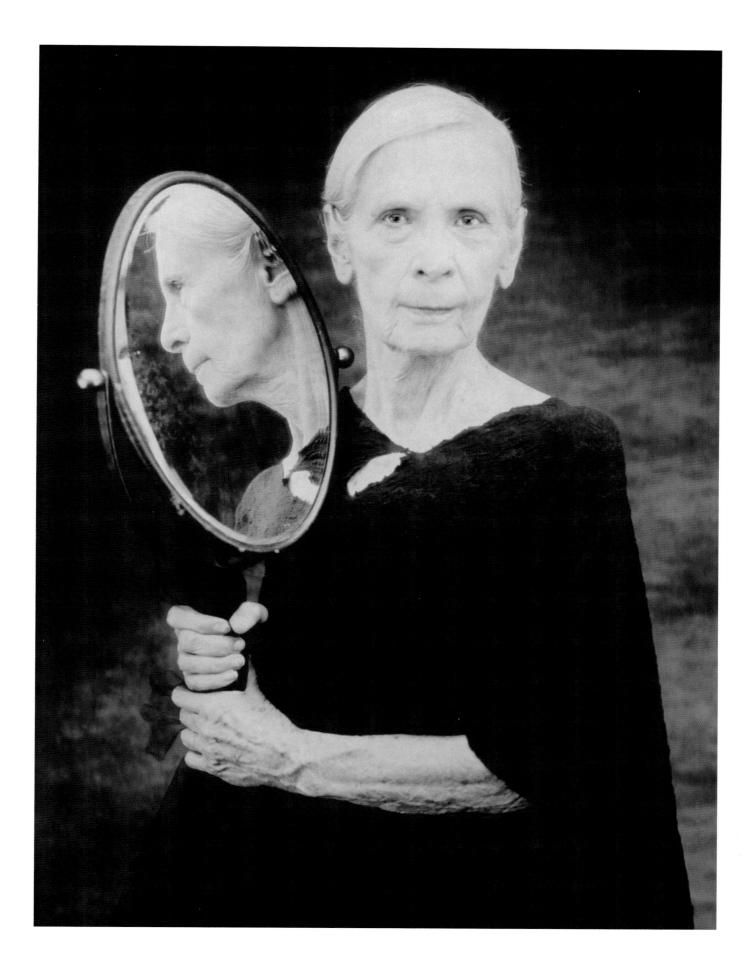

T H E R O A D

A H E A D

"My Celtic ancestors had an intuitive sense of spirituality

illuminated by their closeness to nature. In Maine, where I live now,

I feel a sense of inner belonging. Each day heightens the awareness

of the completing of a circle, and the more I age, the more intense

and stimulating the adventure and the journey become."

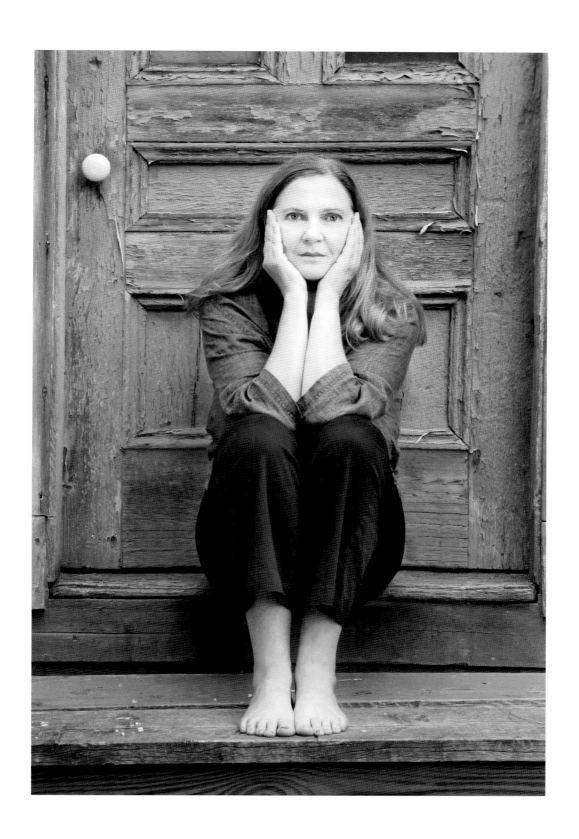

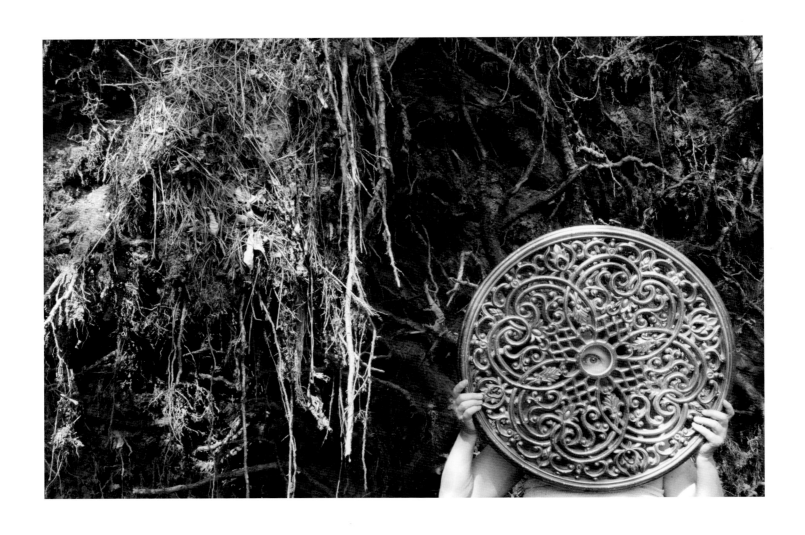

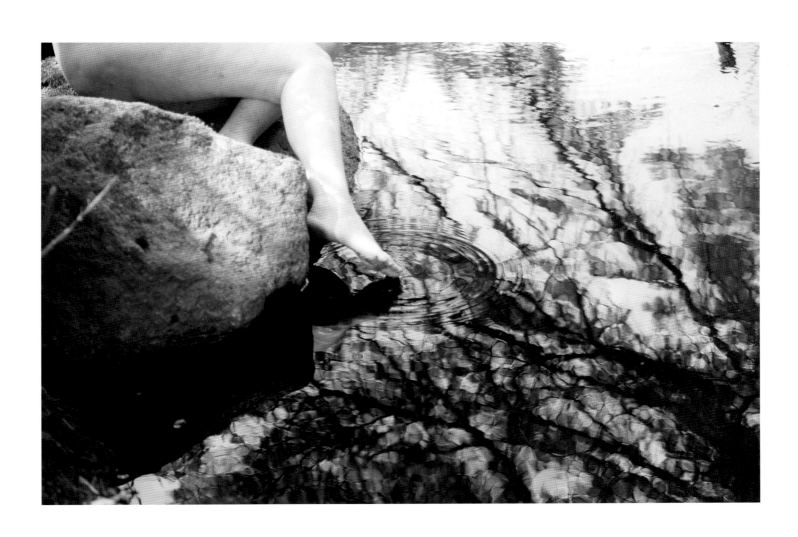

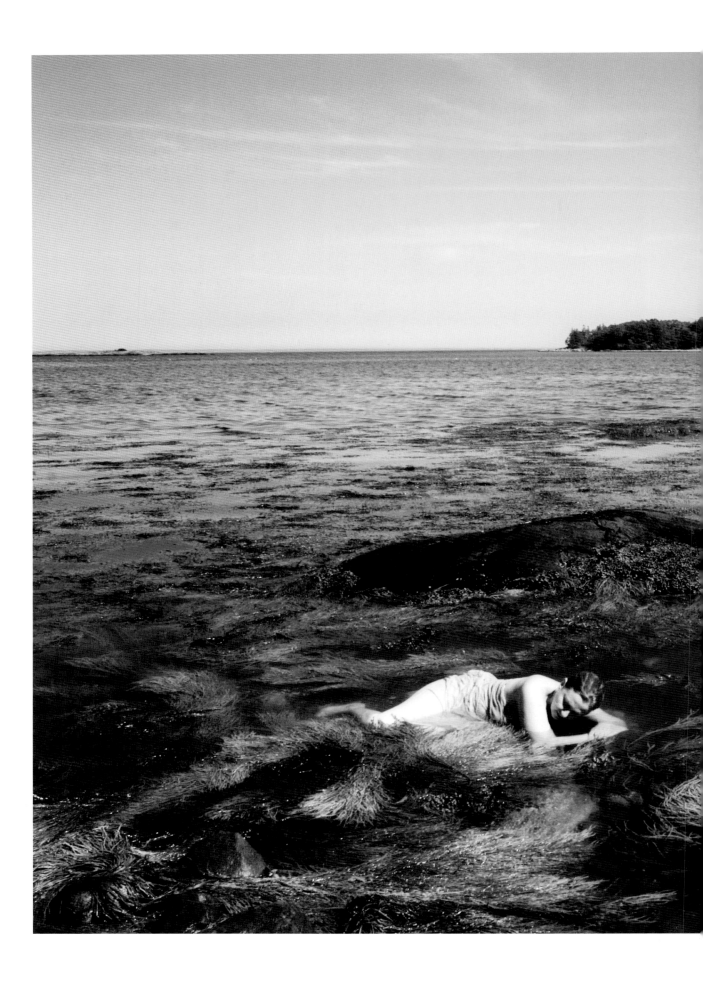

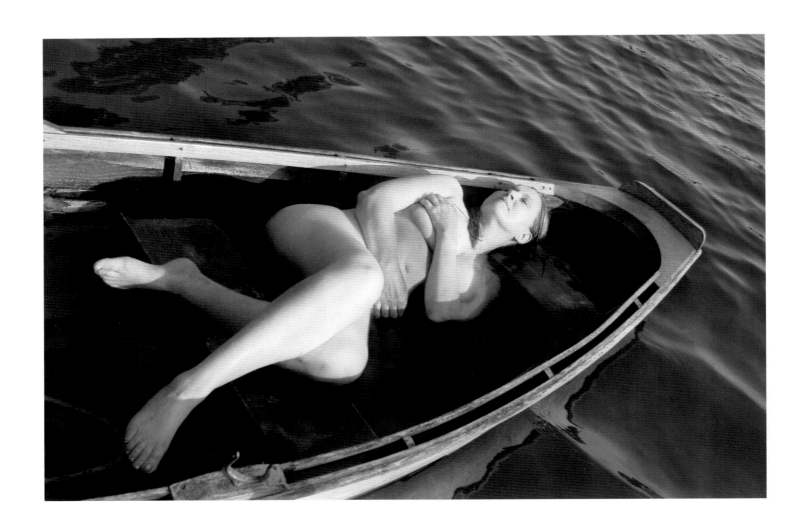

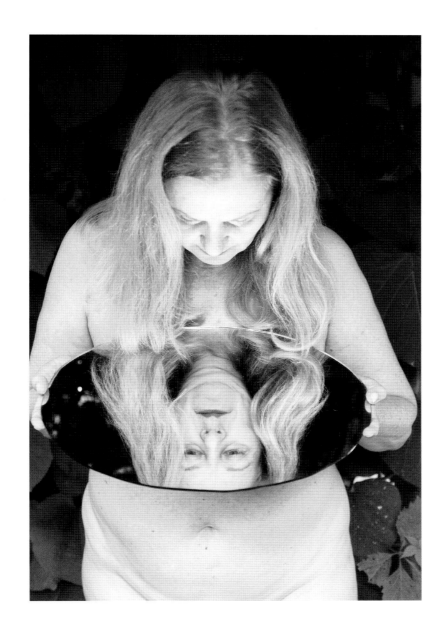

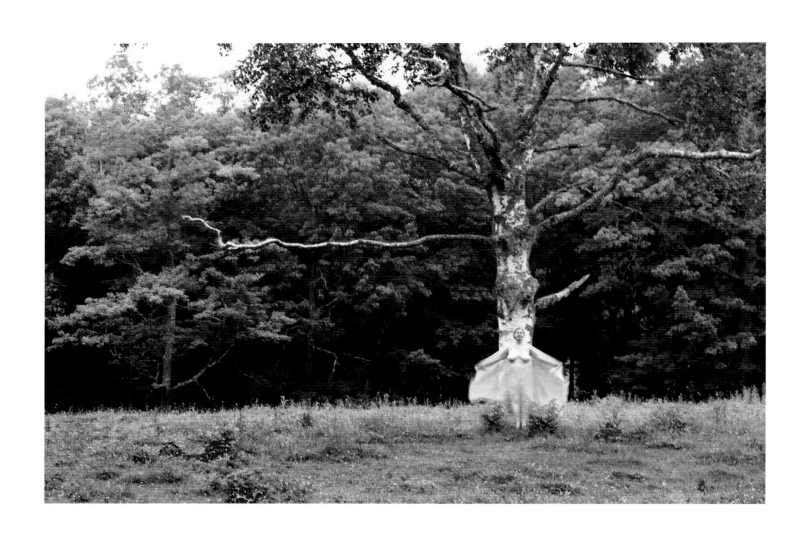

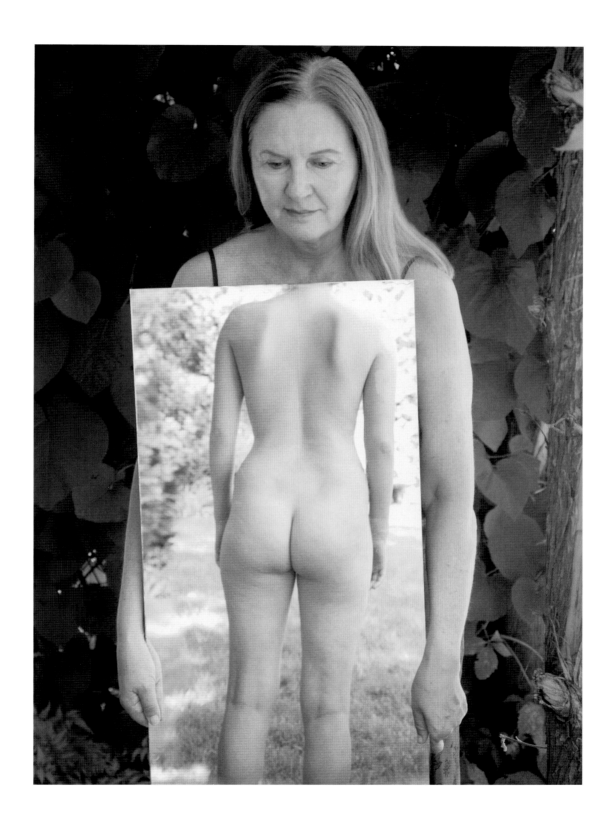

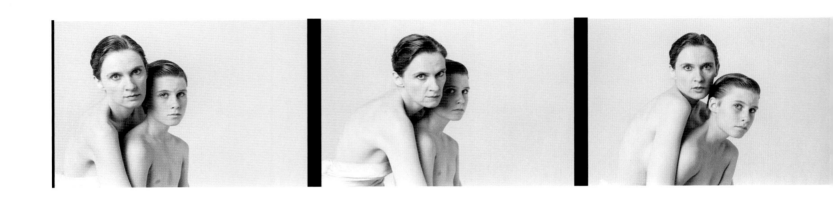

"Having a child gave me a new window on the world,
one of unconditional love. Alex, and now his children,
make my cycle of life complete."

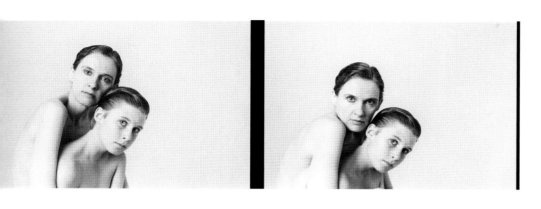

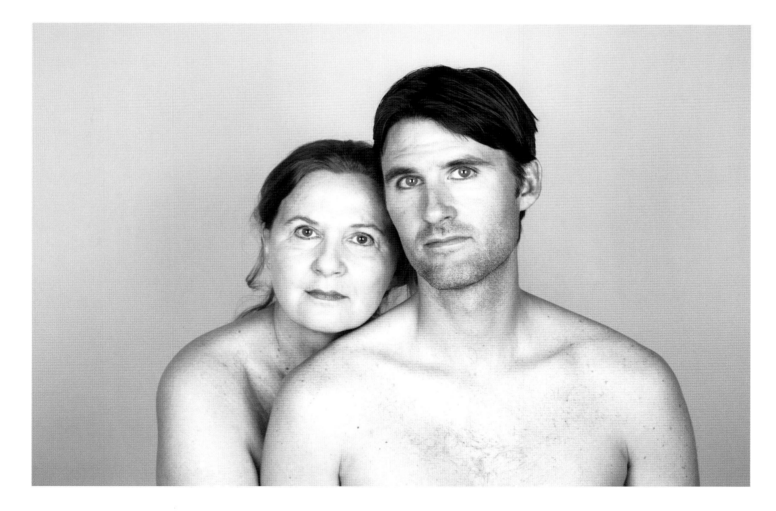

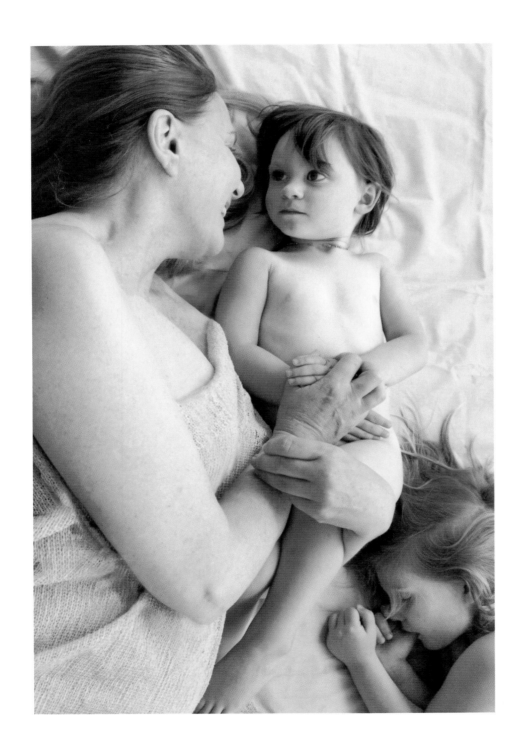

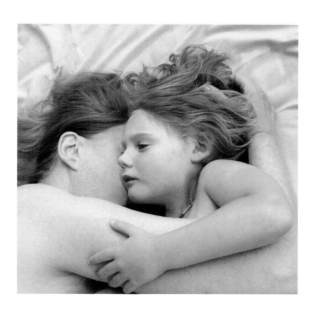
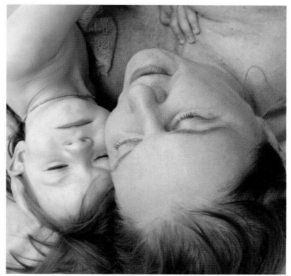

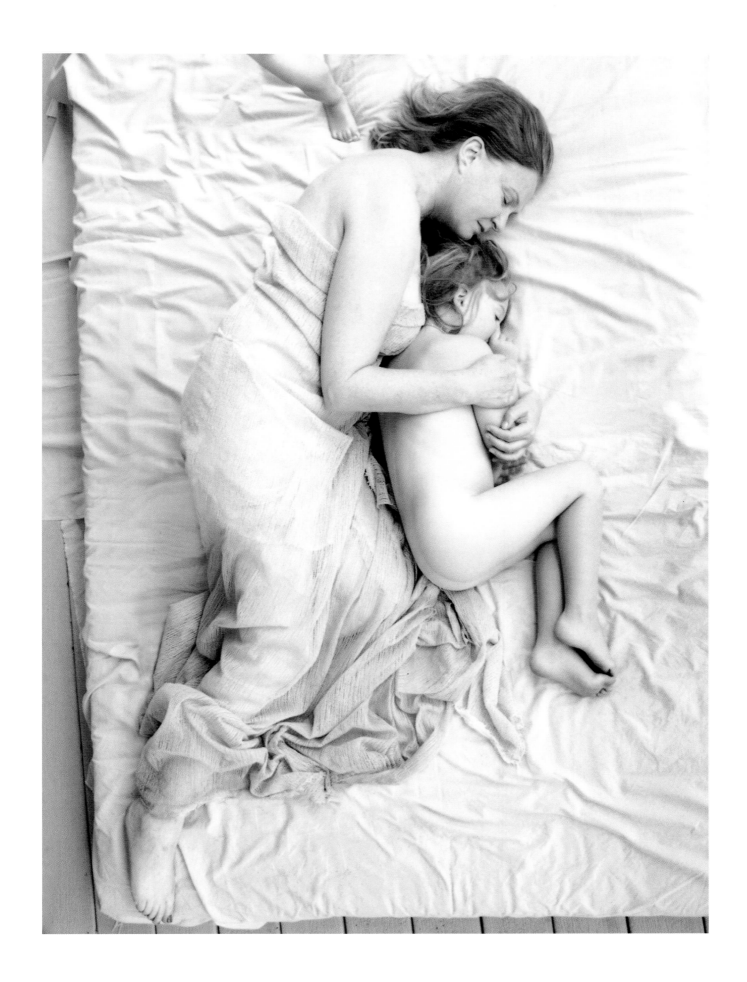

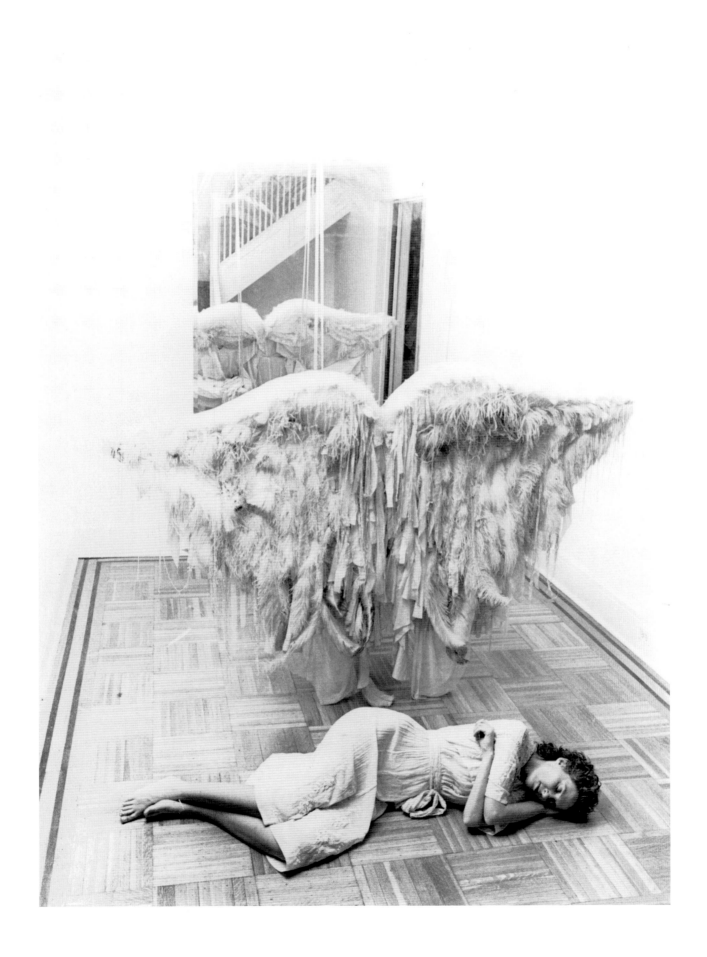

A Life in Photography

While I was in college, I was fortunate to get a part-time job modeling for Polaroid in Cambridge, Massachusetts. They were just beginning to make new color films and needed a test model for their photographers.

At the time, I was a serious student of French literature and had been admitted into a graduate course at Harvard called "The Idea of the Absurd in French Twentieth-Century Literature." I was allowed to sit and study my Camus and Jean-Paul Sartre books at Polaroid, as they needed me only occasionally. I remember thinking how absurd it was for me to inhabit two such different worlds.

On weekends, the male photographers would often ask me to model for them for their "personal" artwork. I soon realized this was not an activity for me. I saw no relationship between the photos they took of me and the person I was deep inside. They had no interest in anything below the surface; I thought I could do better. I asked Polaroid for a free camera, and they gave me all the film I could use. I was like a racehorse that had been let out of the gate. I started shooting and have not stopped for forty years. I fell in love immediately with photography's ability to do quick character studies of people who interested me.

I found inspiration from reading authors like Virginia Woolf and Anaïs Nin. I had always been a voracious reader and might have become a writer if I had not been recruited by Polaroid. The camera became my medium of choice. Photography allowed me to probe and record my own journey of self-revelation. Looking back on my work over the past four decades is like reading a journal. My work has always had an autobiographical edge, most likely because my deepest interest and yearning was to understand the mystery of life. By probing myself, I hoped to uncover universal truths about human nature.

My first ten years as a photographer were intense. I had moved to Washington, DC, to teach and to help put my then husband through medical school. At night I pursued my master's at George Washington University. I tease my assistants now by saying that I

 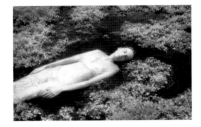

could teach them everything I learned about photography back then in about two weeks. But I have always loved learning, so teaching myself throughout my journey has come naturally.

While living and teaching in DC, I also made thousands of self-portraits—I was compelled. I kept a notebook beside my bed and recorded my thoughts, dreams, and fears—and my loneliness. I had no photographic role models at the time. Photography had not yet blossomed. Young people still dreamed of becoming great American writers—not filmmakers or photographers.

The art scene in Washington was pretty conservative. I was the first woman there to teach photography at the college level, and I felt a lot of resentment and jealousy directed toward me. However, I very much believed in the dictum that "what is most personal is most universal." I tried to work from the center of myself. Photographing became autobiography for me—it was communicating in pictures what authors had always done in their journals and diaries. I read and reread van Gogh's letters to his brother Theo. I identified with his desire to communicate his inner visions. I felt almost possessed to do self-portraits. The resulting photographs were a lifeline for me—they gave life meaning.

To prepare for this book, I unearthed all of these early self-portraits from storage, where they had been banished to for more than twenty years. It was like going on an archaeological dig. While scanning this early work, I suddenly felt compassion for that young woman who had longed to share her secrets and unconscious inner life. It was often painful to

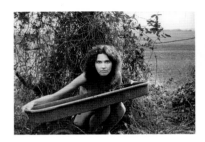 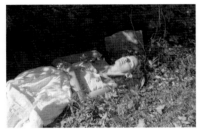 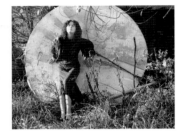

reveal so much of this inner territory. I remember walking through a Francesca Woodman exhibit in Paris decades later and feeling that it could have been I who had jumped out of a window to my death. I am grateful that the invisible forces of the universe seemed to protect me from that possible fate.

I did have a sense that I was dying a slow death in Washington in the 1970s. My work was not accepted. There was a general consensus that photography's real mission and identity lay in its ability to record outer facts, and curators still believed that the photographer should be invisible, that this was indeed possible. We know better now. Photographs are always colored by the intelligence and choices of the photographer who makes them.

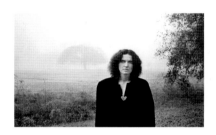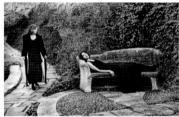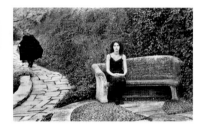

In retrospect, it was probably a blessing that my photographs were not accepted in DC, because this propelled my move to New York. Getting out of town became my salvation. It wasn't easy starting over in New York. It also coincided with a divorce—a very painful event in my life. Looking back, I am not sure how I made it through. I certainly would not want to relive those years.

I have always felt that life is a journey and that the most important thing is to stay on the path regardless of how uncomfortable it may become. As Maya Angelou said when I interviewed her for my book *Wise Women,* "If you're not on the journey, honey, you're not alive!" She's right, but somehow I think I took it all too seriously. I didn't make enough of a commitment to nurturing myself and actually finding joy in life. I really believed that I was a spiritual warrior of sorts. Remaining true to my artistic and philosophical beliefs was what mattered most. Personal happiness never made it to the top of my priorities. I committed myself to being authentic to my own roots and my own internal voice. I do not know where I got the courage to keep pushing these inner boundaries in the face of misunderstanding, but I am grateful.

Breaking into New York was tough for a mother nearing forty. I had to start all over. My only real professional contact was Harry Lunn, the legendary art dealer, who had also recently moved to New York from DC. His gallery had represented my work, and he had been a close friend and an early artist ally. Harry often invited me to dinners he would host at chic restaurants like Café des Artistes and the Carlyle Hotel. He loved good food and wine and delighted in ordering lavishly for the whole table. I was often privy to discussions about the photography marketplace — who was hot and who was not, and who the power brokers were behind them. I remember one dinner when Harry exclaimed to the others at the table, "Who shall we make famous next?!"

Lunn introduced me to Robert Mapplethorpe and his partner, wealthy art collector Sam Wagstaff. He thought we would get along since we were both the same age and recovering Catholics. We all spent a memorable week together in France, where Robert and I were billed as a duo and gave back-to-back slide presentations for one thousand people at the Arles International Photo Festival. I had put my presentation together for a hundred dollars and with lots of help from my students. Wagstaff had paid ten thousand dollars for Robert's to be mounted by a professional audiovisual house. In the end, the audience gave us both standing ovations. Robert was generous in complimenting my work and the fact that I had spoken in both French and English. Wagstaff seemed threatened and hardly spoke to me. This was during my "white period" of the mid-1980s. In the next day's paper, the critics noted that I had spoken from the heart and that the resulting work seemed "*authentique.*" They loved the way this intimate female universe contrasted to the graphic, bold, black-and-white nudes of Mapplethorpe. Harry Lunn took us all to dinner that night, and when I hesitated in ordering dessert, Harry asked the waitress to bring me a taste of everything on the menu. A huge platter arrived as the never-ending flow of expensive wines was uncorked.

Harry was a generous friend, but he was also a mean drunk. I definitely tried to get out of the way when the climate turned dangerous. Although he was married, his French wife lived in Paris with the kids, and this left Harry free to wheel and deal on his own, indulging both his culinary and sexual appetites.

Harry knew I would have a hard time winning over what he called the "Gay Boys' Club" that controlled most of the photo market. He encouraged me to build on my portrait abilities and wait until the tides changed from the existing belief that only formalism and social documentary work were worth collecting.

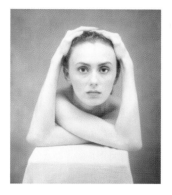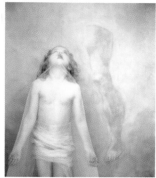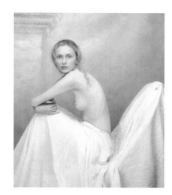

TRANSFORMATIONS

My photographs changed and evolved as I did. When I left DC, my preoccupation with self-portraiture lessened, although my work still felt like a visual psychic diary. *Transformations* (1993), the book resulting from that period of transition, is perhaps my strongest body of work. The photographs emerged almost effortlessly; I often felt that I was merely a channel for their expression.

This series is autobiographical, but in a more symbolic way than the literal self-portraits I took while in Washington. Every so often, as artists, we are gifted with work that seems given by a kind of grace. The best work in *Transformations* appeared in front of my lens in this kind of way. I felt privileged to be a part of that magic moment. One can never will this kind of gift into being.

Since my work has always changed as my life has unfolded, I have never struggled with what to do next photographically. After a book is published, it psychologically releases me to start another chapter in my life and work.

LIGHT WARRIORS

In my next book, *Light Warriors* (2000), my palette shifted from the monochromatic color of *Transformations* to the chocolate brown tones of the earth. I photographed young women in an attempt to see what their spiritual aspirations were—to see if the new millennium brought new visions for us as well.

When doing a portrait, I try to open myself and let the unconscious take over—I don't give my subjects any specific instructions. I just provide a safe space for them to let down their external shield and expose the kernel of their being that is normally secret or hidden.

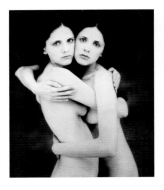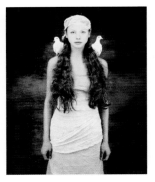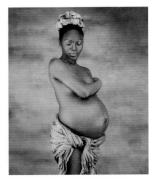

For me, the portrait session is an intimate moment of collaboration where subject and photographer feel free to share their inner selves. I feel privileged to have witnessed and participated in these moments.

COMMERCIAL WORK

During my twenty years in New York, in addition to working on my fine-art book projects, I also took on assignment work. It was a new world for me, and I aspired to do my very best. I felt a bit like a modern-day warrior—it wasn't at all fashionable to blend art and commerce back then. Irving Penn was my only role model. I met with him when I first arrived in New York, and he said that he thought I had the talent to succeed but wondered if I was tough enough to take the hard knocks that inevitably come with the commercial territory. There is a lot of rejection along the way, and that is perhaps why so many aspiring young photographers I have known have not been able to stay the course. I was lucky. I started winning awards in my first year (ICP Best Applied Photography Award, 1989), and I taught myself the necessary business skills to run my own studio. I loved the early years. I did a lot of work for European magazines, flew around the world for major assignments, and somehow juggled

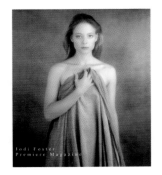

my personal fine-art projects with all of this travel. But along the way, I often lost contact with my soul.

It is tough balancing work from one's heart with work done for a client—as difficult as juggling a demanding career with a meaningful personal life. I always try to see what is best for those I love and find a way to help them on their journey. I have mentored many students and assistants over the years, and those relationships continue to contribute to my life.

WISE WOMEN

After *Light Warriors* was published, one of my assistants asked me what we would work on next. Without thinking, I said, "Let's go to one hundred!" The next day I started *Wise Women* (2002), portraits of women aged sixty-five—normally thought of as retirement age—to one hundred.

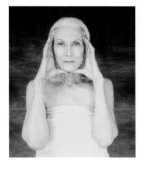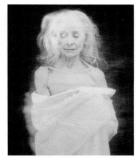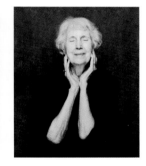

I loved every minute of working on this book. I traveled from Maine to Montana, photographing and interviewing women from many cultural backgrounds and all walks of life. I had no idea what to expect. The popular media uses negative phrases like "over the hill" or "gone to seed" to describe older women. After doing more than three hundred interviews, I found that most of these women said they had never been happier—they felt more confident, freer, and had often transformed their priorities to find ways to give back to the world in a meaningful way. Most said they were no longer willing to hide behind a mask. They told me to tell readers that they would never want to go back to their twenties, thirties, or even forties—unless, of course, they could take their hard-earned wisdom with them.

The book was an immediate bestseller. The *Today* show did a six-part feature on *Wise Women,* and the book has continued to inspire others all over the globe.

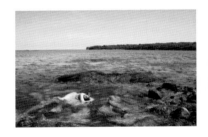 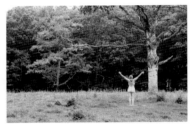 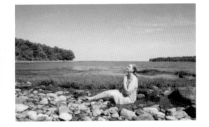

THE ROAD AHEAD

As I enter my seventh decade, I am grateful for everything that has brought me to this point — the darkness as well as the light. I am a very different person from the fragile woman I see staring back at me from my early self-portraits. When I left Washington, I wrote in my journal, "I want to see if I can bring a sense of the spiritual into the world of commerce." At this point in my life, I had to make a choice between two completely different paths. One was building a new life on my love of the transcendent, going deeper into the healing arts. The other was going to New York and using my photography to bring a sense of the spiritual to a wider audience.

Following the New York path has made me grow in ways I would have never dreamed possible. I have traveled around the world working on assignments and book projects that have taught me about other cultures and brought more compassion into my being. I have met royalty and Nobel Prize winners, as well as those in poverty and those with serious illness. After twelve books, my heart longs for another kind of fulfillment. I would like to explore the other interests I left behind years ago, when I decided to travel and do battle in the competitive New York world of art and commerce.

To continue growing has always been my mission. The passion I once felt for scaling the heights of my present career path has diminished. I feel free to move on, to seek different summits. The outward journey has less interest for me now. I spend half of my year in Maine, where my studio overlooks the water and I feel close to nature.

I want to learn how to surrender to the yearning of my heart and soul again. I feel as though I have completed a full circle in my life and art. I feel I can fly now, like I always dreamed of doing. Perhaps the price of flight is staying true to your own destiny and completing the inner journey to become whole. Photography and teaching will always be important parts of my life, but I am now excited to explore new frontiers. I leave my ultimate destination up to destiny. It will be a different kind of journey, leading inevitably, I suspect, to new, unimagined places.

Joyce Tenneson, June 2007

LIST OF PHOTOGRAPHS

My heartfelt thanks to everyone who has contributed to my life
and participated in my work over the years.